GOD in Unexpected Places

GOD in
Unexpected Places

Reflections on Faith and Life
from MARYKNOLL *Magazine*

Joseph R. Veneroso

ORBIS BOOKS
Maryknoll, New York 10545

Founded in 1970, Orbis Books endeavors to publish works that enlighten the mind, nourish the spirit, and challenge the conscience. The publishing arm of the Maryknoll Fathers and Brothers, Orbis seeks to explore the global dimensions of the Christian faith and mission, to invite dialogue with diverse cultures and religious traditions, and to serve the cause of reconciliation and peace. The books published reflect the views of their authors and do not represent the official position of the Maryknoll Society. To learn more about Maryknoll and Orbis Books, please visit our website at www.maryknoll.org

Library of Congress Cataloging-in-Publication Data

Veneroso, Joseph R.
 God in unexpected places : reflections on faith and life from Maryknoll magazine / Joseph R. Veneroso.
 p. cm.
 ISBN 978-1-57075-709-9 (pbk.)
 1. Meditations. I. Title.
 BV4832.3.V46 2007
 242--dc22

 2006035009

FNM rocks!

*I dedicate this book of photo reflections
to the Friday Night Meeting (FNM)
of the Youth Group
at St. Paul Cheong Ha-Sang's
Korean Catholic Church in Flushing, New York.*

*Since 1985, their idealism and enthusiasm have been a constant
source of inspiration and encouragement to me.*

수고들!

About the Author

Ordained in 1978,
Father Veneroso served in Korea until 1985,
when he returned to the States to
begin working with Maryknoll *maga̧ine.*
Since then he has also assisted on weekends with the
Korean Catholic apostolate.

CONTENTS

ACKNOWLEDGMENTS

In gratitude

First and foremost, to Frank Maurovich, editor of *Maryknoll* magazine, who for many years was a "voice in the wilderness" calling for publication of these photo meditations in book form;

To Michael Leach, former executive editor of Orbis Books, for encouraging this effort and linking it to the celebration of *Maryknoll* magazine's 100th anniversary in 2007;

To Nancy Kennedy, administrative assistant, for painstakingly keying in the text; and to Marge Gaughan, managing editor of *Maryknoll* magazine, for her "terminal scrupulosity" in making sure these pages remained free of typos and other egregious errors;

To Roberta Savage, head of our art department, for rearranging the text, typefaces and images to enhance the central message of each piece and work as a whole;

To Rodney Swanger, manager of Maryknoll's image resources, for supplying or substituting breathtaking photos from Maryknoll's extensive photo library, which provide a visual yin to my verbal yang;

To artists Gerry Braatz, Alicia Grant, Jan Golden, Roger Clark, Ponie Sheehan and John Roper who originally laid out the photos and texts for maximum effect when they first appeared in *Maryknoll* magazine;

To Brother Dave McKenna, M.M., who diligently searched countless files for pictures to illustrate the themes.

To the many award-winning freelance photographers whose artistic vision captured the beauty of our mission world. See their individual credits on page 144.

To Catherine Costello, from Orbis Books, for patiently shepherding this project to completion.

And of course to the loyal readers of *Maryknoll* magazine who have responded so enthusiastically to these photo meditations over the years.

My sincerest thanks.

INTRODUCTION

As a child I enjoyed drawing pictures so much I once dreamed of becoming an artist. I loved using crayons, watercolors and oil paints. Trying to capture on paper the subtle shades of a branch of sumac in autumn taught me to appreciate form, texture and shape as well as various hues. Highlights and shadows provide an essential yin and yang, each bringing out the best of the other.

Music was another passion of mine. I wasn't particularly good at it, but I enjoyed singing in the choir, and my belabored trumpet lessons at least taught me to celebrate rhythm, timing and cadence. As with art, I also developed a respect for silences and empty space. These overlooked qualities make sense of expression. Without these, art and music disintegrate into chaos.

It came as quite a jolt when Maryknoll asked me in 1985 if I would be willing to study at Columbia University Graduate School of Journalism. Talk about a grinding of gears. Words? Grammar? Communication?

Since getting my degree in 1987, I have put my newly acquired journalistic skills into practice by reporting on mission stories around the world for *Maryknoll* magazine.

Our extensive photo library contains more than a million images, many stunningly beautiful yet with no accompanying story or caption. That's when I hit upon the idea of expressing spiritual truths underlying the pictures through poetry. Now I could apply the sounds and silences of music to the taste and resonance of phrases. With the English language as my palette, I started painting with words.

This collection of my photo reflections comes with my prayer that you who enter into its pages discover new ways of looking at the world and people around you. May my work inspire you to consider all aspects of life and in them discover God.

Joseph R. Veneroso, M.M.

CHAPTER 1

CREATION'S RITE OF LIFE

Imagine the excitement if a space probe to Mars sent back pictures of a single blade of grass. The implications would be mind-boggling. The possibility of life on other planets has always intrigued us. We long for assurance that we are not alone in the vast emptiness of space and that some intelligent life "out there" may be trying to contact us.

As Christians, we believe an Intelligent Life is trying to communicate with us, but not just from "out there." Our Creator communicates to us through all of creation. "The heavens declare the glory of God," the psalmist sings. "All the earth proclaims God's salvation."

Why look to Mars for signs of life when we live on such a beautiful sacrament as Earth? Each creature—the lowly ant no less than the majestic whale—should fill us with wonder at the power and wisdom of the One who created them—and us.

For if the smallest living thing merits respect, how much more so human life, whether within the womb or wise with age? Surrounded by miracles, we should celebrate and protect God's revelation of creation. "Ecologist" and "Pro-Life" are just different ways of saying, "I believe in God."

Who Is Like God?

I stand at the edge of a vast and mighty sea.
At times the sheer size of the crashing waves
 and pounding of the surf
 take my breath away.

At other times the surface is so calm and smooth
 it mirrors the moon
 and I am awed
 that one so great could be
 so perfectly still.

It bids me enter and frolic.

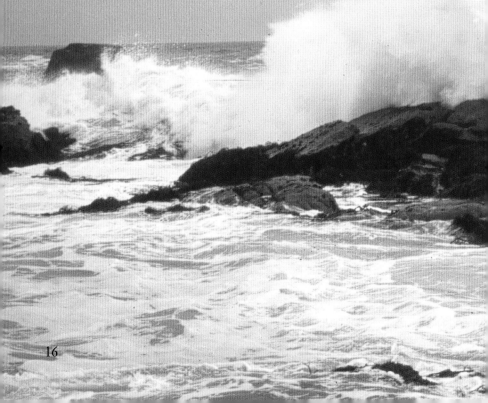

And I am neither lulled by the apparent peace
 nor cowed by the surging tides.
Rather, a profound respect for its as yet unplumbed depths
 gives me pause.
Yet all that I have seen and heard and felt,
 even in the midst of sudden squalls and raging tempests,
 has been so good, so beautiful, so pure, so holy,
 that I am drawn to go deeper.

Knowing I am in way over my head and may very well drown,
 still I do not fear.
For what would death be but to dissolve and become totally one
 with that which I most love?

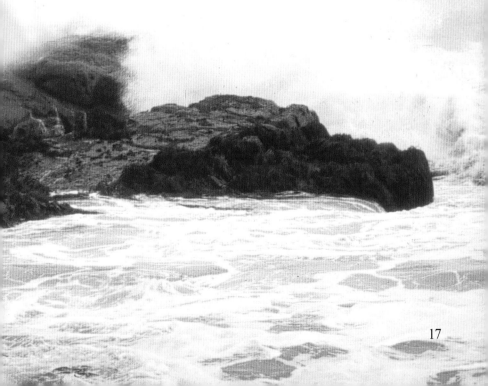

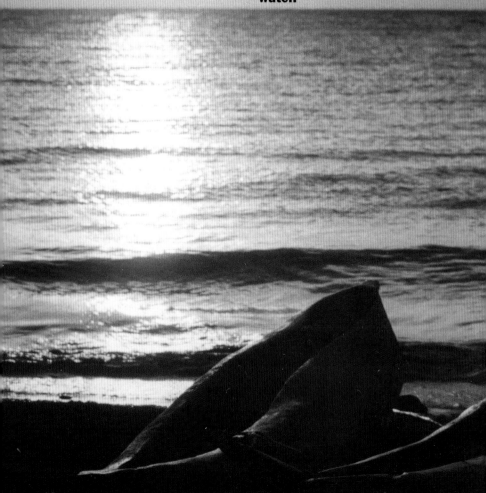

And so I celebrate all I have experienced
and bless all that is yet to be revealed.
And in this loving trust, my eyes ever fixed
upon the One who calls
I step boldly forward and

walk

on

water.

Blessing the Now

The universe inhales, a snowflake falls,
galaxies collide, a flower blooms, fades,
a bird sings, the cosmos reels,
autumn leaves turn
death and life
eternal duet.

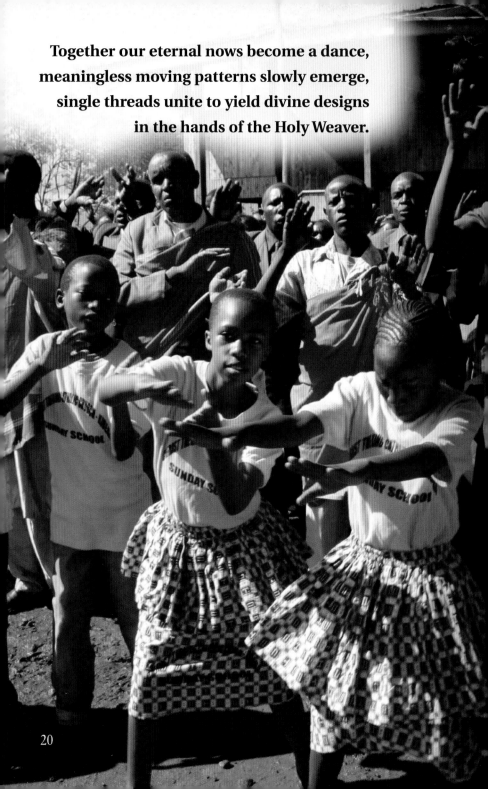

Together our eternal nows become a dance,
meaningless moving patterns slowly emerge,
single threads unite to yield divine designs
in the hands of the Holy Weaver.

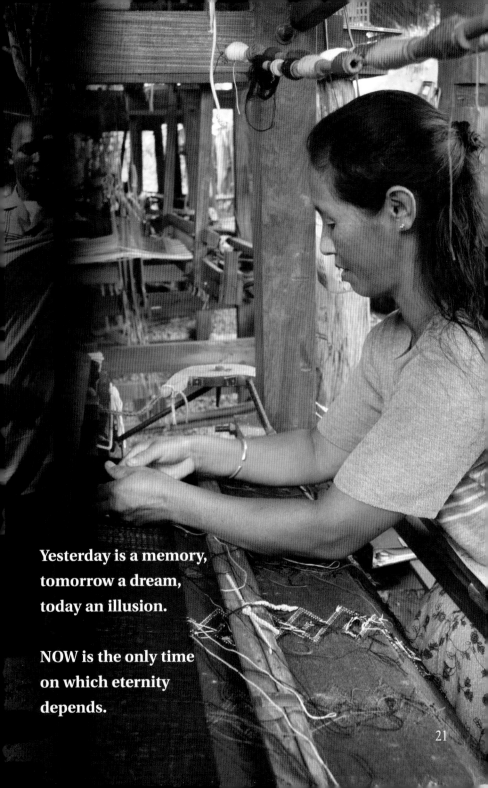

Yesterday is a memory,
tomorrow a dream,
today an illusion.

NOW is the only time
on which eternity
depends.

21

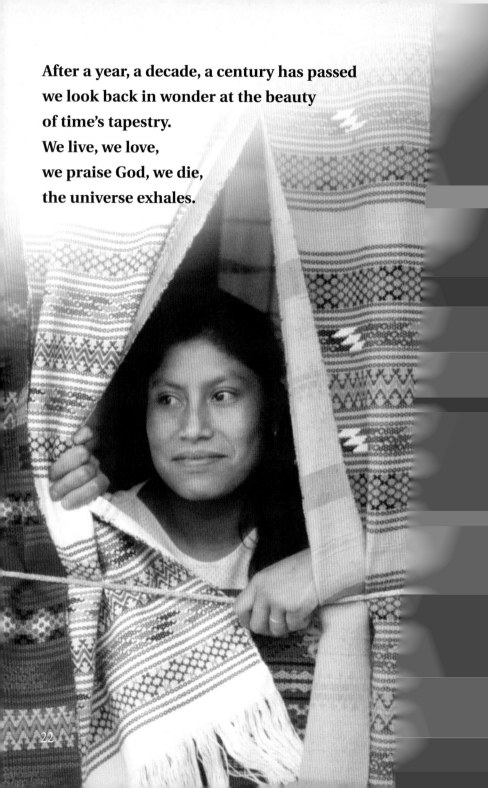

After a year, a decade, a century has passed
we look back in wonder at the beauty
of time's tapestry.
We live, we love,
we praise God, we die,
the universe exhales.

The Gospel according to Earth

Consider how flowers
follow the Son.

Faces mirror the image
and likeness of the One
worshiped.

Containing in each
petal the first glorious
mystery of the universe.

Feeding hungry birds
and forgiving
all too eager children
without questioning
wants or worthiness.

Living side by side
with weeds and thorns,
neither envying the
rose nor disdaining
the dandelion.

Content for the day.

Fallen seed dies, rises
reaches heavenward.

Seasonal cycle of grace
and redemption.

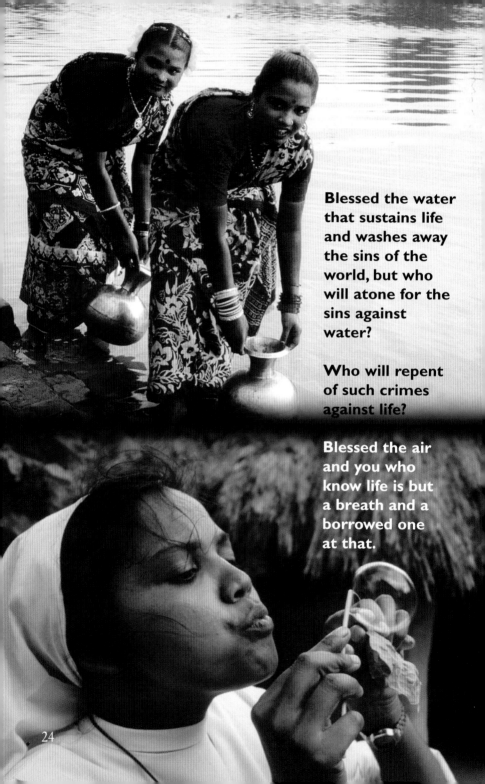

Blessed the water
that sustains life
and washes away
the sins of the
world, but who
will atone for the
sins against
water?

Who will repent
of such crimes
against life?

Blessed the air
and you who
know life is but
a breath and a
borrowed one
at that.

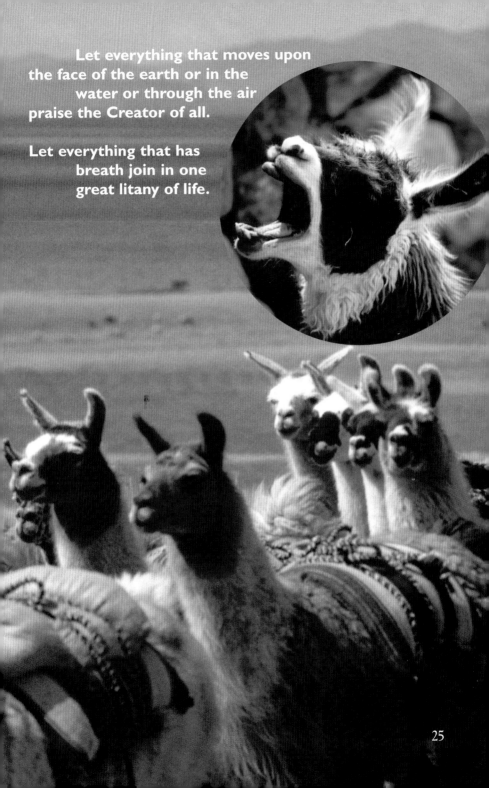

Let everything that moves upon
the face of the earth or in the
water or through the air
praise the Creator of all.

Let everything that has
breath join in one
great litany of life.

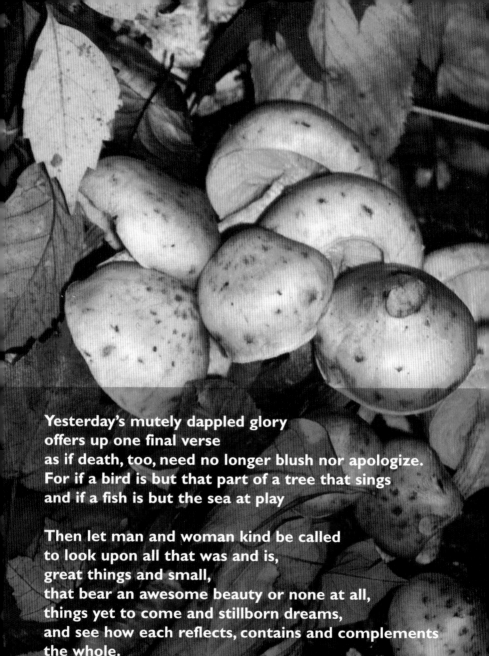

Yesterday's mutely dappled glory
offers up one final verse
as if death, too, need no longer blush nor apologize.
For if a bird is but that part of a tree that sings
and if a fish is but the sea at play

Then let man and woman kind be called
to look upon all that was and is,
great things and small,
that bear an awesome beauty or none at all,
things yet to come and stillborn dreams,
and see how each reflects, contains and complements
the whole.

And let them bless and not withhold the Great Amen

Lord,
It Is Good for Us to Be Here

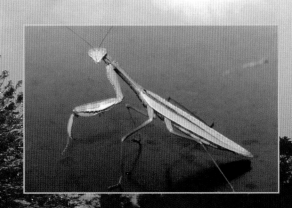

Some distant mountain beckons: Climb! Conquer!
Capture the truth! But my feet hesitate. A praying mantis,
mini-masterpiece of God, crosses my path, regards my shadow
as if it were cast by some distant mountain.

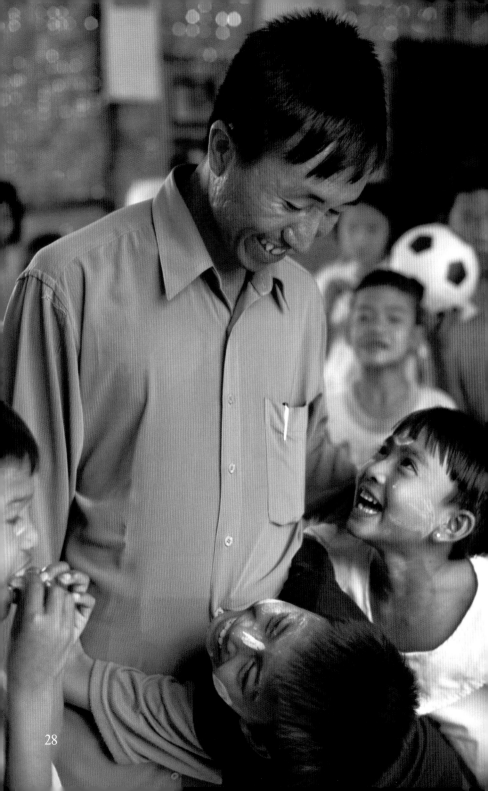

No need now to climb.
Truth has come to us in human form:
God in Jesus in Mary
in us in the world –
natural tabernacle.

God speaks the Word.
Our lives join together in sentences of grace;
our prayer a paragraph.
Laughter of youth,
sighs of age:
chapter and verse
of living Scripture.

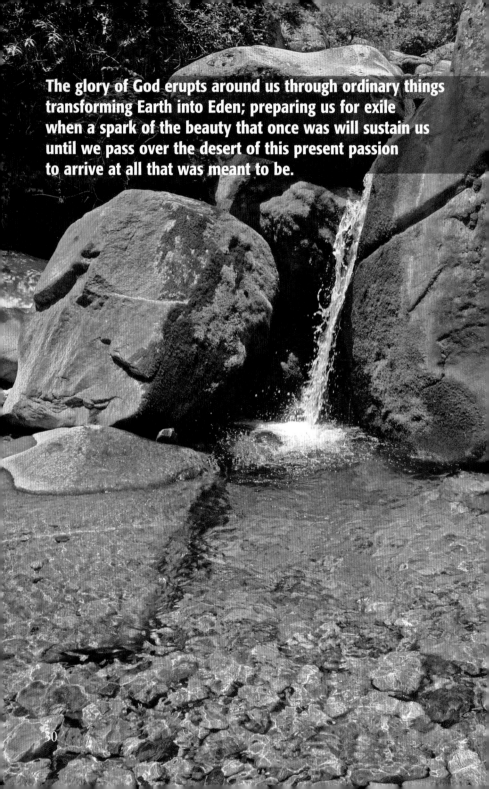

The glory of God erupts around us through ordinary things transforming Earth into Eden; preparing us for exile when a spark of the beauty that once was will sustain us until we pass over the desert of this present passion to arrive at all that was meant to be.

Litany
of
Water

Sustainer of all life
Servant of death
Quencher of thirst
Carrier of disease
Sculptor of canyons
Melter of mountains

Mother of nations
Source of every civilization
Maker of history
Protector of cities
Bane of invading armies
Divider of continents
Supporter of commerce
Symbol of divinity
Lifeblood of humanity
Ever-changing, ever-changeless
Mirror of time.

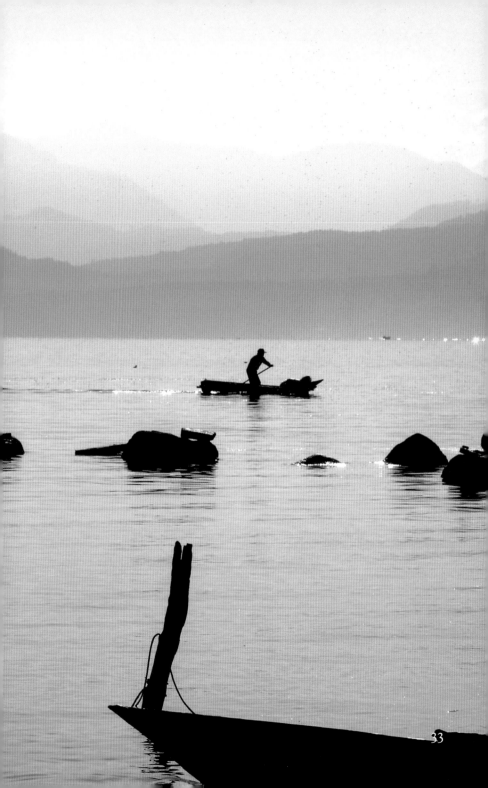

You do not disdain our feeble attempts to master or control you

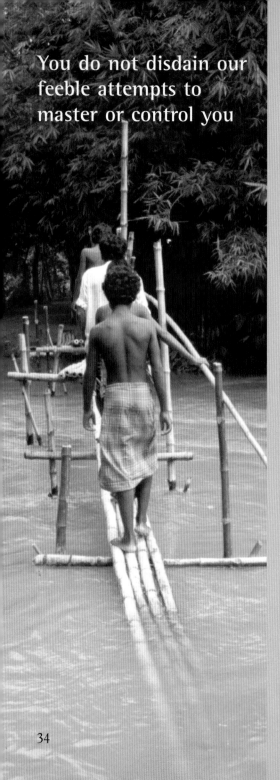

You water our fields and refresh our gardens

You let us play in your waves, cool our tired feet in your brooks and renew our spirits in your fountains

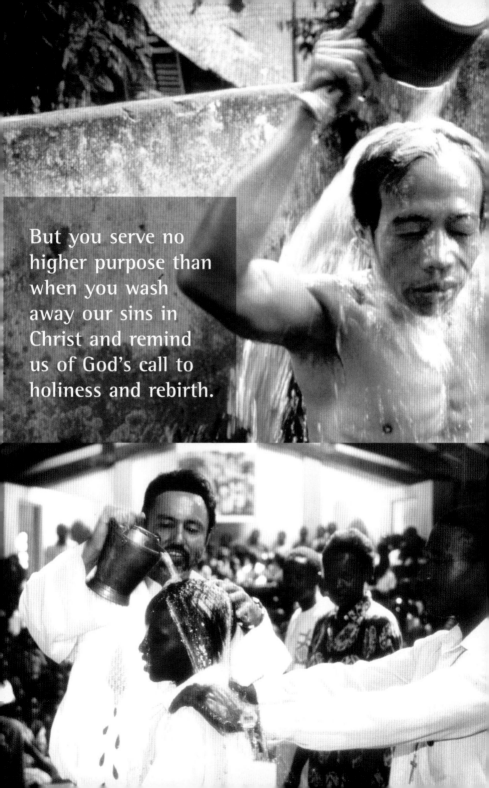

But you serve no higher purpose than when you wash away our sins in Christ and remind us of God's call to holiness and rebirth.

Creation's Covenant

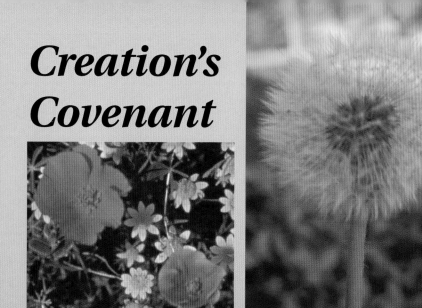

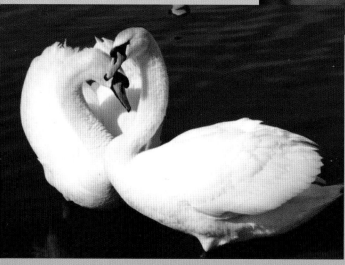

Not content with perfecting the orchid, no,
God insists on a world awash
in daisies and dandelions.
Not satisfied with a simple sparrow
God imagines eagles, ostriches and swans
then throws in a penguin or two
just for fun.

God continues to create a universe of miracles
for us to discover, savor and enjoy
where a single blade of grass
or grain of sand
contains the secrets of the stars
and a century for the tortoise
or single day for the gnat
is time enough.

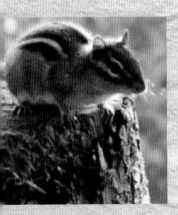

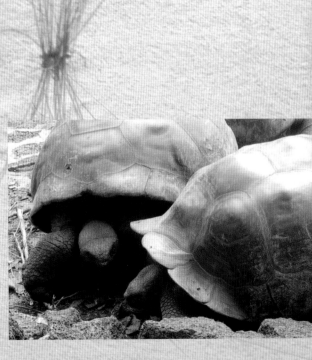

Listen to the symphony of languages
while gazing at our human family
through kaleidoscope eyes.
See reflected in a million different faces
this sublime truth:
not all rainbows arch the skies.

L
E
N
T

A
Season
of
Emptiness

What if we spent these 40 days subtracting
from our lives every thought, word and deed
not from God
 Who am I minus me

What if we spent these 40 days
living as if we had to make up
what is lacking in the suffering of Christ
Weeping not for him but for our children
Wiping the face of him in whose image we were made
Standing at the foot of his cross

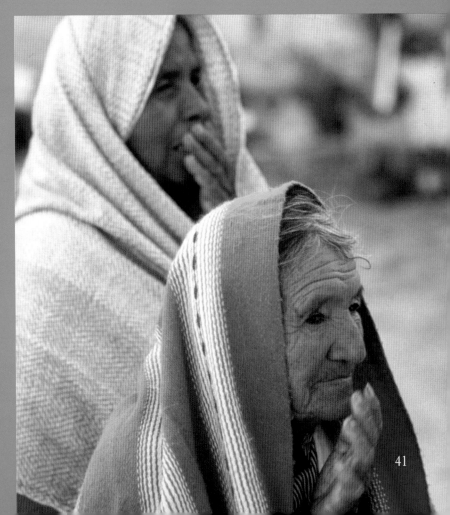

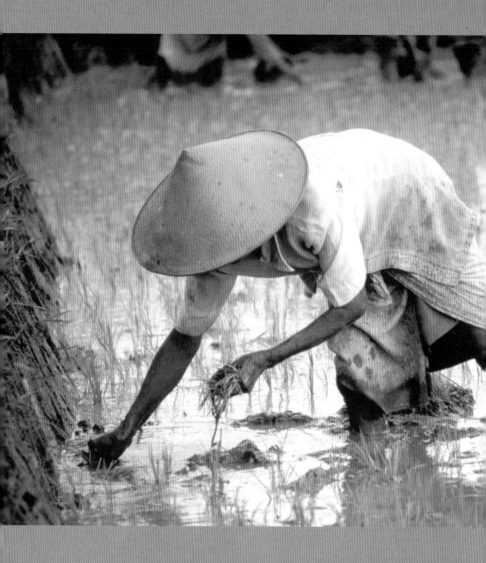

Looking for our true Self somewhere between
planting and reaping

Looking forward to the hand of the harvester
with dreadful hope

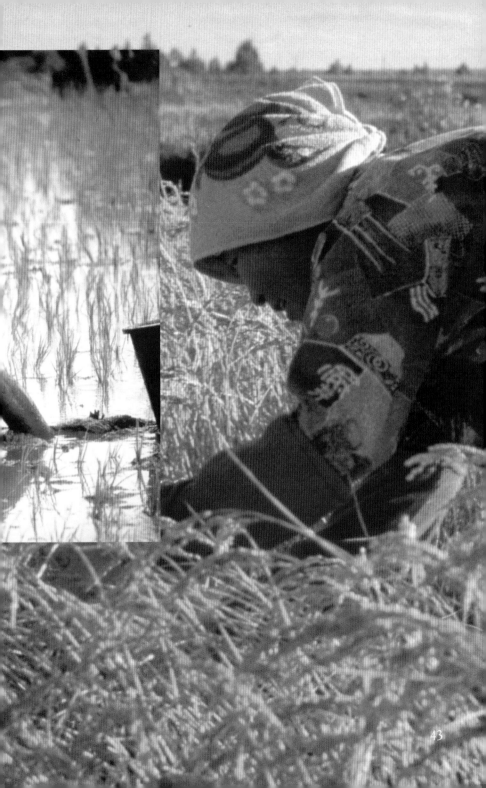

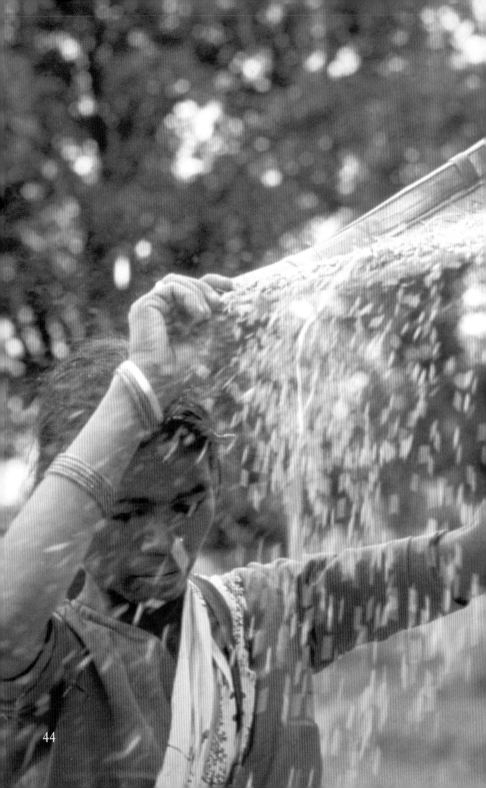

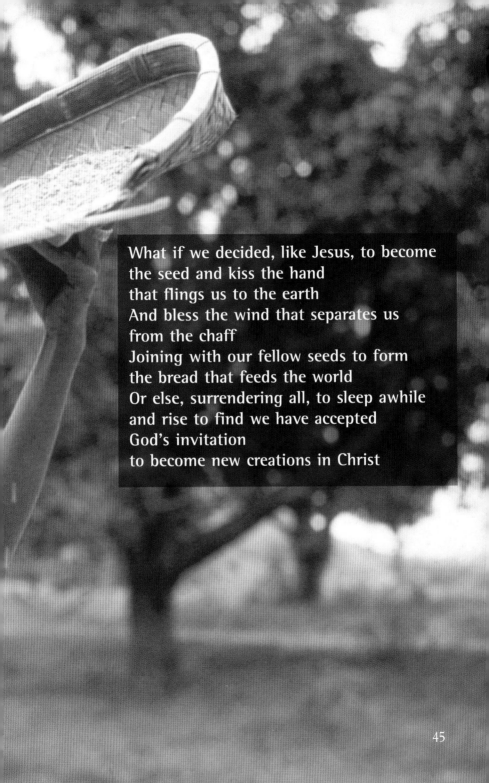

What if we decided, like Jesus, to become
the seed and kiss the hand
that flings us to the earth
And bless the wind that separates us
from the chaff
Joining with our fellow seeds to form
the bread that feeds the world
Or else, surrendering all, to sleep awhile
and rise to find we have accepted
God's invitation
to become new creations in Christ

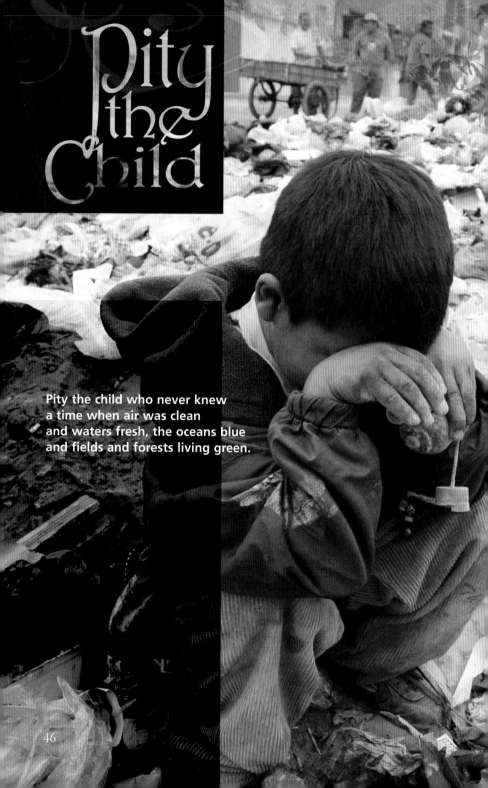

Pity the Child

Pity the child who never knew
a time when air was clean
and waters fresh, the oceans blue
and fields and forests living green.

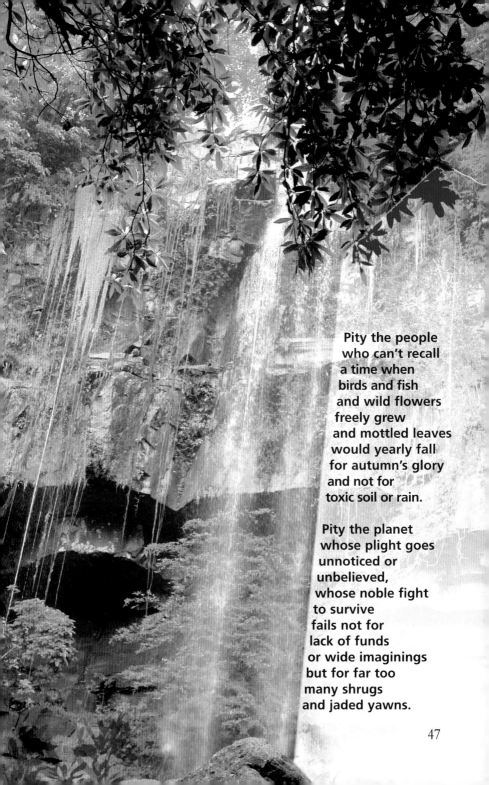

Pity the people
who can't recall
a time when
birds and fish
and wild flowers
freely grew
and mottled leaves
would yearly fall
for autumn's glory
and not for
toxic soil or rain.

Pity the planet
whose plight goes
unnoticed or
unbelieved,
whose noble fight
to survive
fails not for
lack of funds
or wide imaginings
but for far too
many shrugs
and jaded yawns.

47

Pity our Creator God
whose handiwork collapses
under the strain,
whose Eden groans, gasps and finally dies
leaving incredulous choirs of angels
to chant Earth's requiem.

Pity.

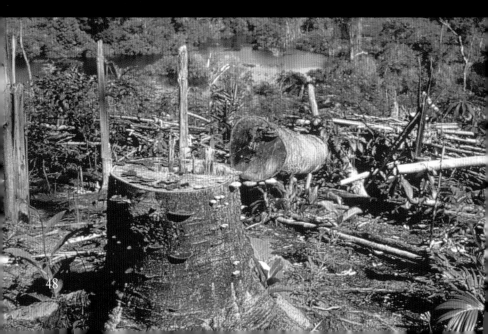

CHAPTER 2

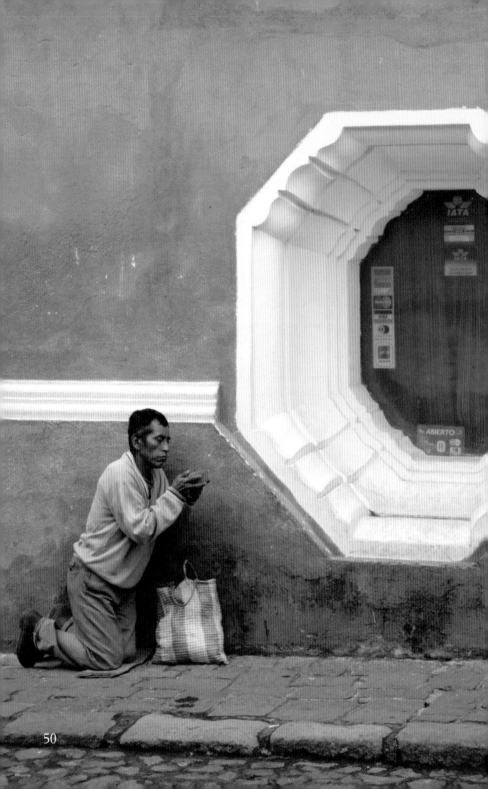

HEAVENLY OUTCASTS

According to legend, when Moses confronted Pharaoh with the command, "Let my people go," the king of Egypt asked in which god's name this Hebrew upstart demanded freedom for slaves. When told "Yahweh," Ramses II had his high priests recite the list of all known gods. This "Yahweh" was nowhere to be found. Moses chided, "Why do you seek the living among the dead?"

With no power other than that of the God of Slaves, Moses led the people to freedom.

How is Yahweh different from all other gods? Yahweh is not the God of the rich or of the upper ruling class. Rather, Yahweh identifies with the poor, the oppressed and the weak. Yahweh—not military might, economic prowess or cultural achievement—is the sole glory and salvation of the Chosen People.

What God does reveals who God is. God constantly reminds us, "I am Yahweh, who led you out of Egypt, that place of slavery."

Do we worship the one, true and living God? More than our theology, more than our religious affiliation, more even than what we call God, our lives provide the answer.

When we refuse to pay homage to wealth and power, but rather oppose oppression, we honor the living and liberating God. When we live free from the slavery of sin, we worship the one, true God. When we treat outcasts like our brothers and sisters, when we speak truth to power with the age-old cry, "Let God's people go!" we show how Yahweh is unlike all other gods. This is the joyful and urgent message of all missioners and all Christians for all ages.

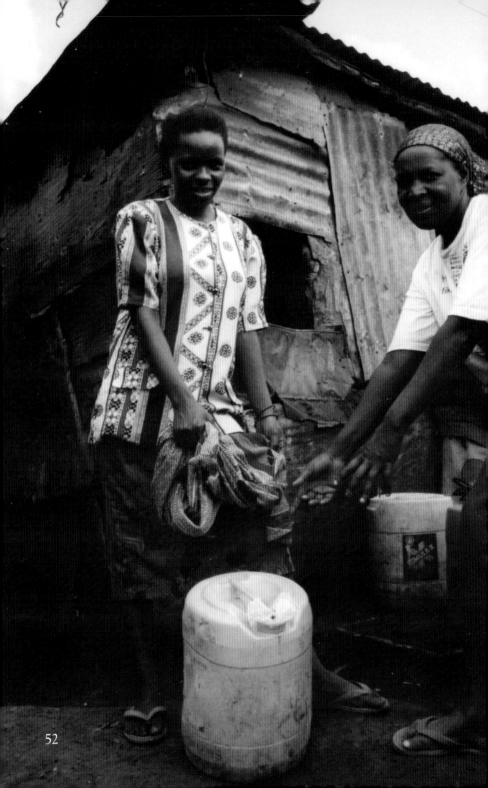

Looking for God in All the Wrong Places

I searched for God in my heart, not quite convinced
I'd find anything of worth or holy there.
And I was right—or so I thought.

I looked for God in my home with greater doubt
the Lord of Hosts would dwell amid such messy madness,
no matter how great the joy or strong the bonds of love.
And sure enough the Lord eluded me again—or so I believed.

So I took my quest to fields afar,
confident the farther I went,
 the more desolate the desert,
 the starker my surroundings,
the greater my chances of finding the One
who alone could make me whole.

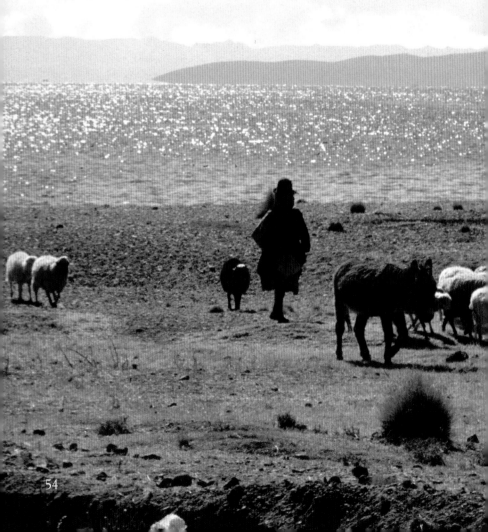

I climbed each sacred mountain,
I fasted and prayed and
 offered sacrifice
 before various altars at sundry shrines.
I chanted, sang or kept silent,
doing works of charity along the way
—all to no avail.

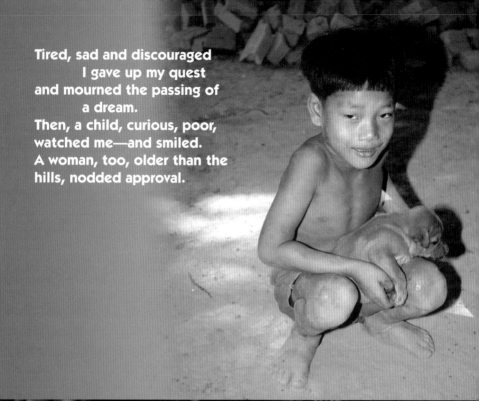

Tired, sad and discouraged
 I gave up my quest
and mourned the passing of
 a dream.
Then, a child, curious, poor,
watched me—and smiled.
A woman, too, older than the
hills, nodded approval.

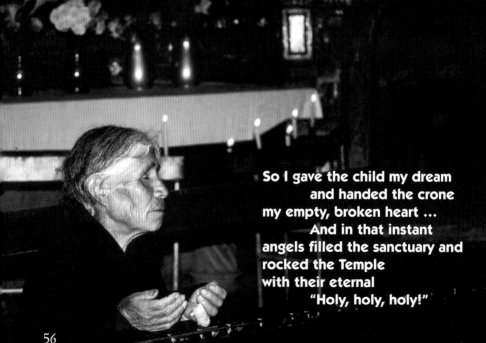

So I gave the child my dream
 and handed the crone
my empty, broken heart ...
 And in that instant
angels filled the sanctuary and
rocked the Temple
with their eternal
 "Holy, holy, holy!"

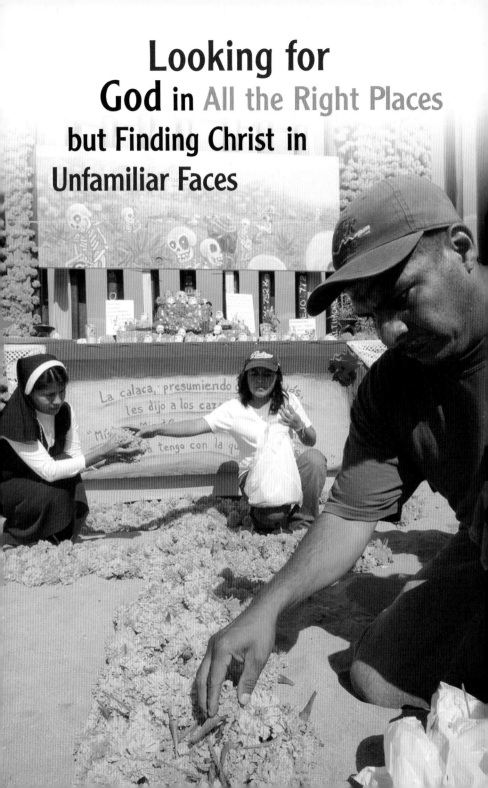

Looking for God in All the Right Places but Finding Christ in Unfamiliar Faces

Funny thing about God's grace / it isn't bound by time or space / nor limited by creed or race / nor slave to poor imagination / truth bigger than all of creation / underlies the Incarnation: / God is one with us / God is one of us.

The poor, the sick, the blind, the lame / those without jobs or wealth or fame / these are the ones for whom Christ came / Experience has been my mentor: / God's not found in the dead center / no matter what some may allege /

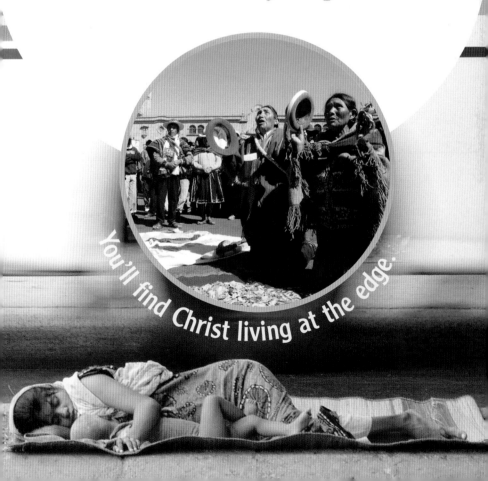

You'll find Christ living at the edge.

Not Daring to Believe

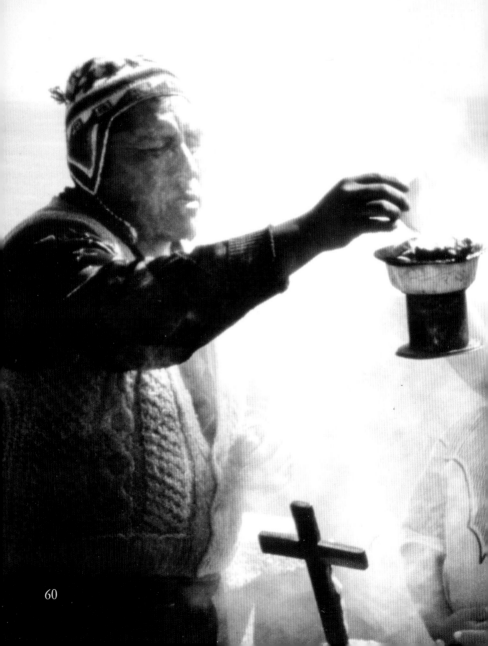

We call you by a thousand names
hoping you'll answer to one.
Ancient rites, sacred sounds, holy smoke—
anything to get your attention.
We even kill one another to prove to ourselves
our way is best.

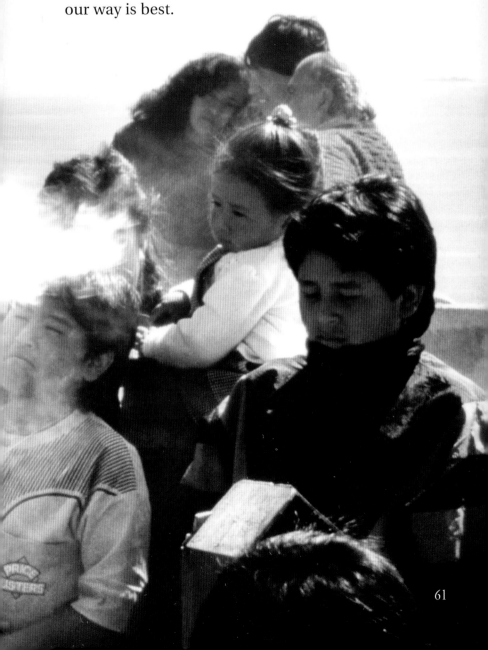

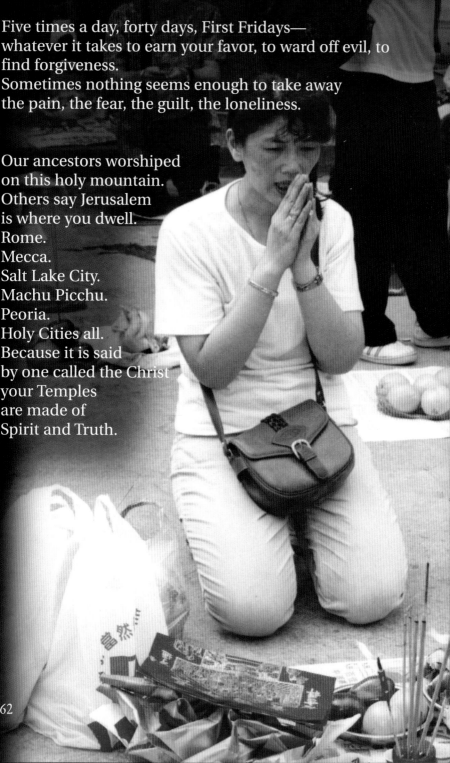

Five times a day, forty days, First Fridays—
whatever it takes to earn your favor, to ward off evil, to
find forgiveness.
Sometimes nothing seems enough to take away
the pain, the fear, the guilt, the loneliness.

Our ancestors worshiped
on this holy mountain.
Others say Jerusalem
is where you dwell.
Rome.
Mecca.
Salt Lake City.
Machu Picchu.
Peoria.
Holy Cities all.
Because it is said
by one called the Christ
your Temples
are made of
Spirit and Truth.

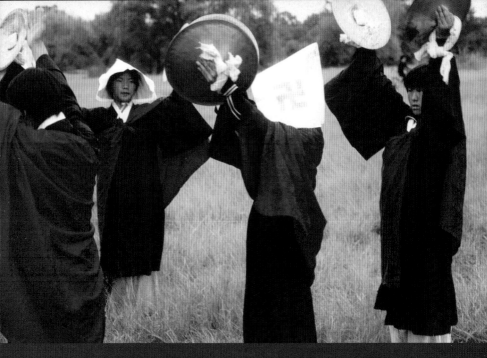

Do all our chants,
our hymns and dirges
merge and form
one harmonious
never-ending
Hosanna?
Do the stars and
galaxies vibrate to
the rhythm of our
sacred dance or is it
the other way around?

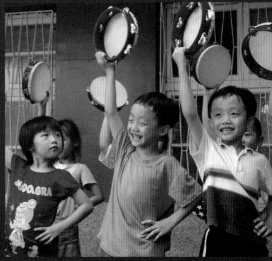

Are all our rituals
and prayers
just so much noise
to keep you an eternity away
locked in some distant heaven?
Do we fear to face
the unsettling truth
that you are with us here?

Do we take you at your Word
or does your Word take us
where we would rather not go?
We would sooner worship you bathed in
unapproachable light
sitting on your celestial
throne surrounded by
multi-winged Seraphim of
terrible beauty and
indeterminate gender than
face a divine absurdity:

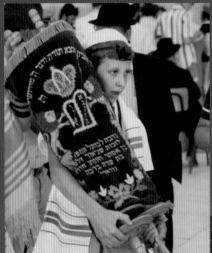

We are not only
created in your
image; you are
like us in all
things but sin.

All our pomp
and processions,
novenas and
adorations,
sacrifice and
penances cannot
bring us closer
to you—or you
to us—than when
we simply whisper,
"Abba."

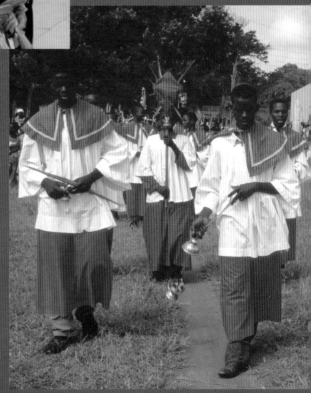

What's Right with This Picture?

Where is God in all this? I wonder.
In the constant flow of cool, clean, refreshing water or
in a simple smile of pure delight?
Too easy.

Any fool can see—
as I often do—
God reflected in the
sunset or enthroned in a temple
of canyons or rosebuds.
No, God is here, in the highlights
soft on this child's hair
and innocence.

Here, in the passing down.
Here, in a mother's touch.
Here, in a father's awkward
tenderness.

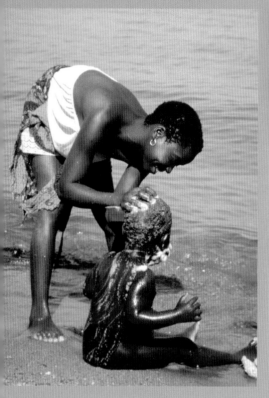

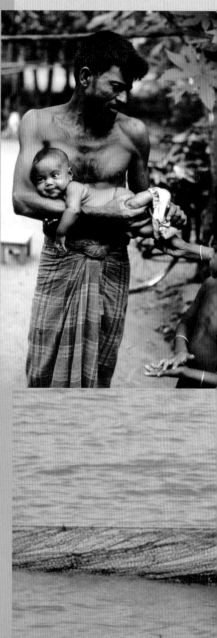

Not so much
in the crashing of waves
as in the gentleness of the surf
caressing the sand
and teaching us
how to love without
breaking.
Here.

Not in alpine majesty nor lakes serene but here
in the undying hope
deep within the fisherman's heart
who casts his net again and again and again
into an indifferent and unsympathetic sea.

Here
when the eye of fated prey meets that of predator
and the silence says, "You know as well as I
my defeat, like your victory, is an illusion."

Here
when with his final breath a dying man whispers
"Forgive."

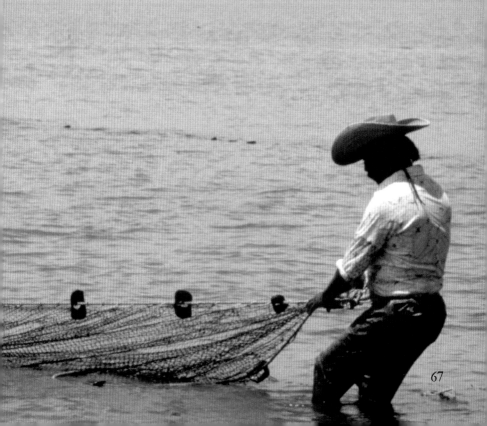

67

Where is God in all this?

Where isn't God?

God, who enlightens
every man and woman
in the world

who shines in our
darkness and is not
overcome

who becomes flesh and
pitches his tent among us

Whose glory we have
seen with our own eyes
and heard with our
own ears and have
touched, taken and
eaten.

Where is God in all
this?

Not on the cross.
Not in the empty tomb.
Here.

Nursery Mimes

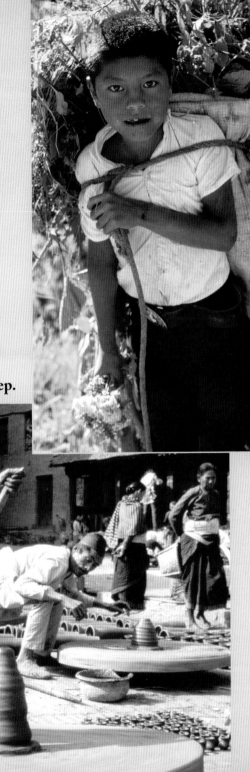

O sing a song of children
A-working in the field
Dreaming of a better life
The earth will never yield.

Visions of tomorrow
Instead of games to play
When memories of sorrow
Will seem a world away.

There's no need to worry
There's no need to weep
Our children are all equal
—At least when they're asleep.

*L*ittle Miss Smiles

Walked
seven miles
to see what she
might find.

Gathering wood
as fast as she could

Sure took a load
off her mind.

A frustrated tyke
astride her bike
feet reaching not pedal
nor floor.

Along came a buddy
who got his hands muddy
'cause that's what a buddy
is for.

*F*reddy Flash
was short of cash
but that didn't stop him
from making a splash.

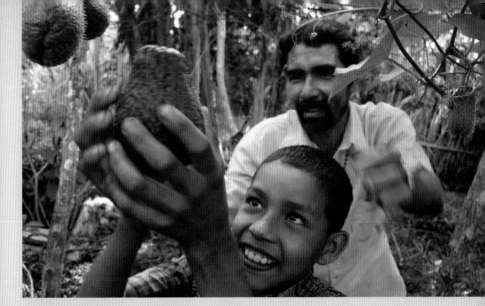

*K*ids in Chile, kids in Greece
Kids in Timbuktu
Kids in China, kids in France
Kids in Kenya too
Give their parents great respect,
love and joy
—Do you?

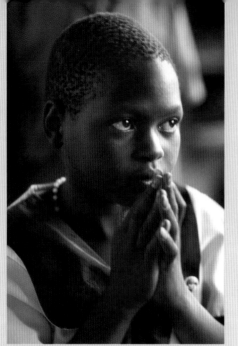

*S*imon says to honor God
With body, mind and soul
The good earth as our
 starting point
And heaven as our goal.
To love our neighbors
 as ourselves
Wherever they may be.
For all the children
 of the earth
Are just like you and me.

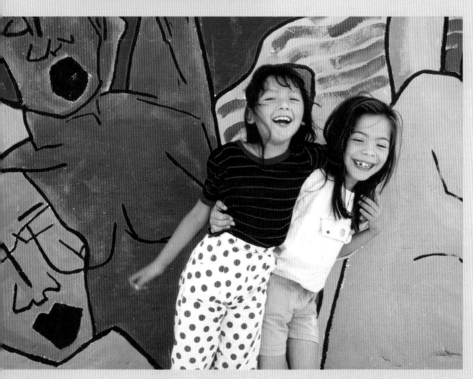

No Hands but Yours

People yearn for the touch of hands
that help and heal and do not harm.
People long for love that liberates
and lasts as long as life itself.
People cry to heaven for justice
wondering who listens or answers.
People hunger for a word of truth
in a world drowning in deception.
People search for peace
not knowing it can only come
through prayer
and reconciliation.
People confuse certainty
with faith and
sacrifice freedom
on the high altar
of security.

God asks,
"If not you,
WHO?
If not
today,
WHEN?"

To Such as These

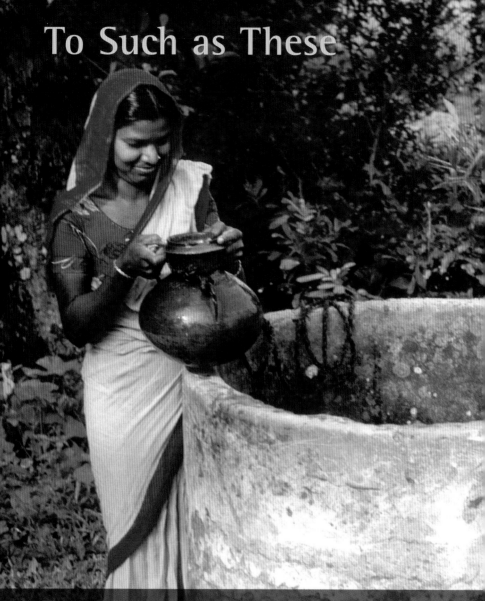

Driven by thirst, habit, custom, tradition,
a that's-the-way-it's-always-been so stop complaining
mother-in-law of karma, she comes again and again
to draw water. From deep and ancient wells
she seeks renewal, refreshment, cleansing.
To such as her the Messiah came.

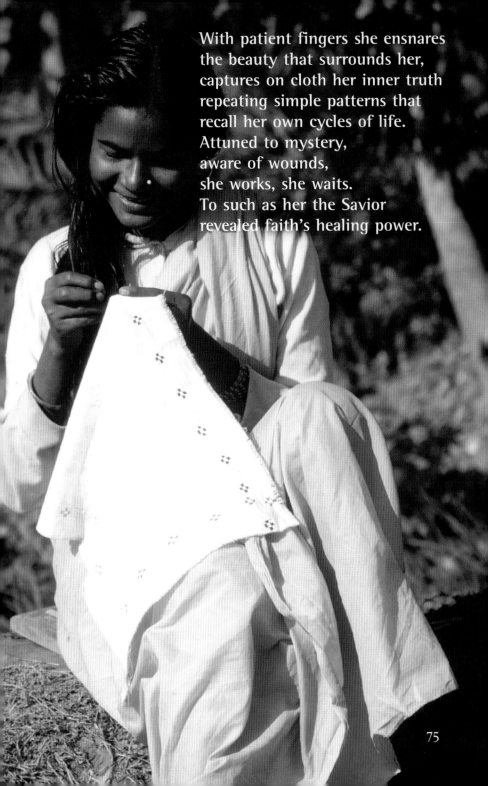

With patient fingers she ensnares
the beauty that surrounds her,
captures on cloth her inner truth
repeating simple patterns that
recall her own cycles of life.
Attuned to mystery,
aware of wounds,
she works, she waits.
To such as her the Savior
revealed faith's healing power.

Having proven her worth by bearing sons
she merits no rest. Working mother must provide
food and clothing as well as care and comfort
till these apples of her eye are grown
and married to women like her who will, God willing,
take their rightful turn at toil and relieve her burden.

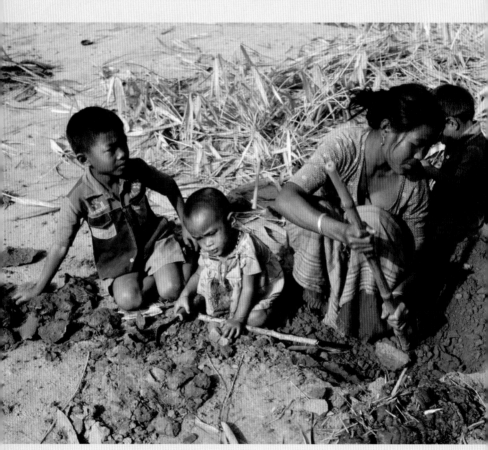

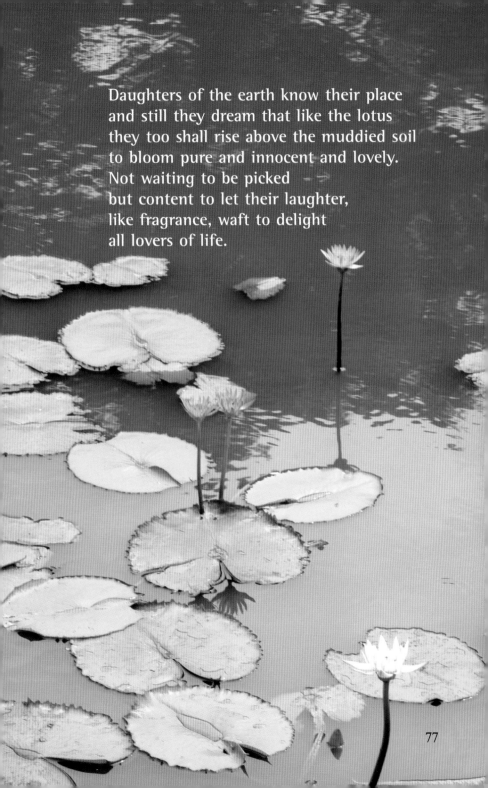

Daughters of the earth know their place
and still they dream that like the lotus
they too shall rise above the muddied soil
to bloom pure and innocent and lovely.
Not waiting to be picked
but content to let their laughter,
like fragrance, waft to delight
all lovers of life.

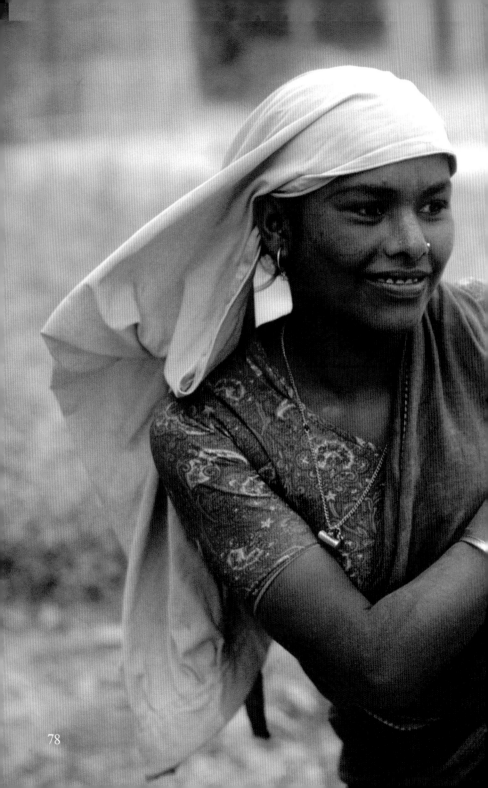

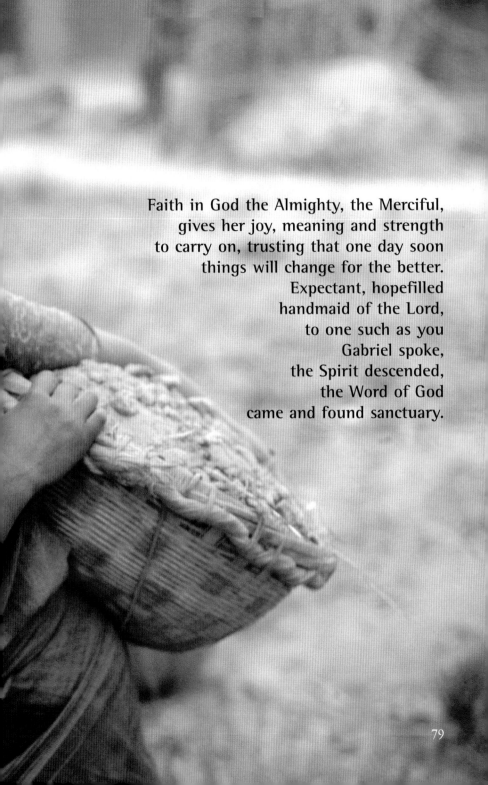

Faith in God the Almighty, the Merciful,
gives her joy, meaning and strength
to carry on, trusting that one day soon
things will change for the better.
Expectant, hopefilled
handmaid of the Lord,
to one such as you
Gabriel spoke,
the Spirit descended,
the Word of God
came and found sanctuary.

Spreading the Word

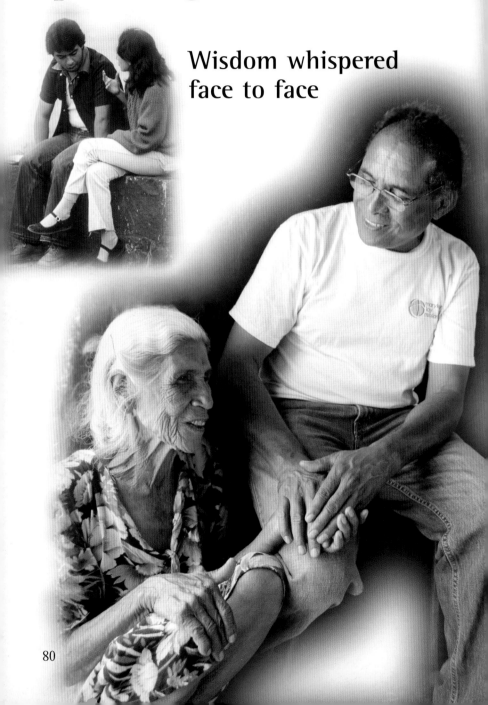

Wisdom whispered
face to face

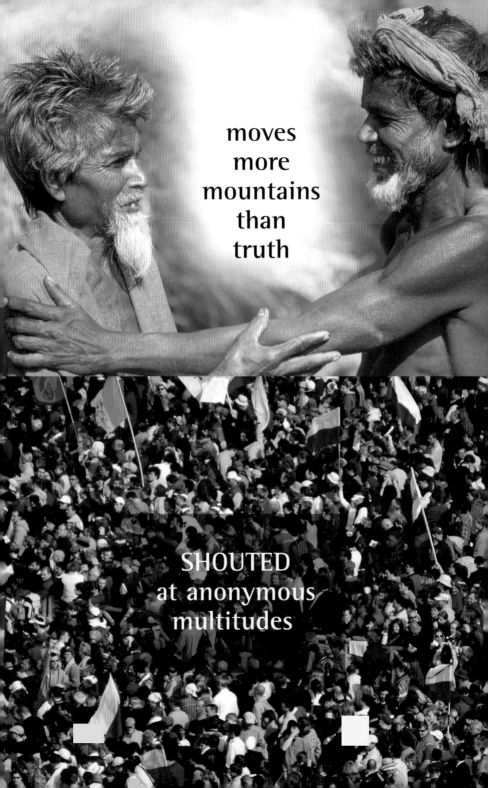

moves
more
mountains
than
truth

SHOUTED
at anonymous
multitudes

Healing the Body of Christ

Unheard, unheeded, Christ's desperate plea
on the night before he died
not for some megachurch of blank conformity
but one where, despite our sorry pasts of self-inflicted pain,
humility and love trump our stubborn pride.

We who take, bless, break and eat the Body of the Lord
become mere fragments of a greater family of faith
reunited only when we seek and find all who belong
and participate in an even holier communion of hope and joy.

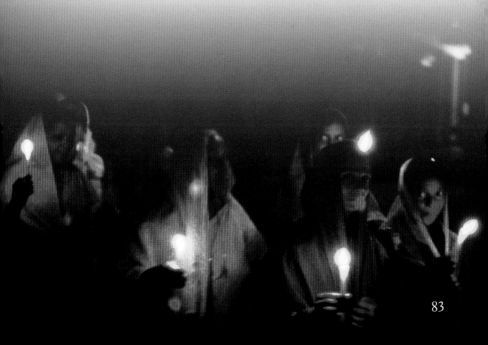

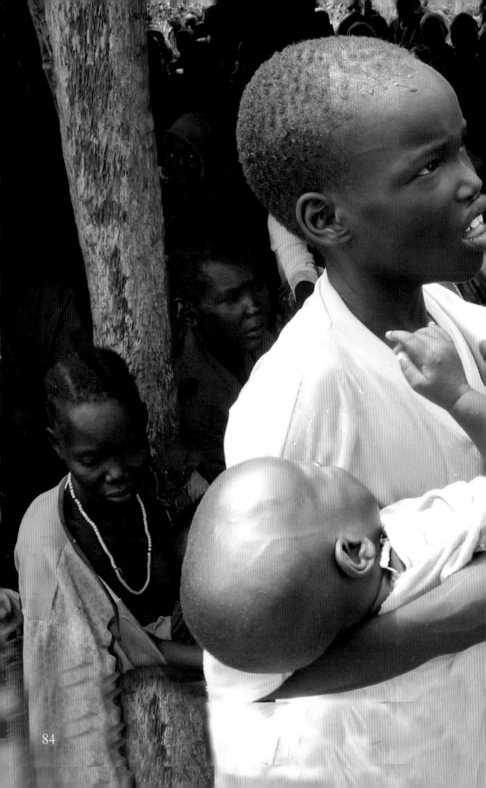

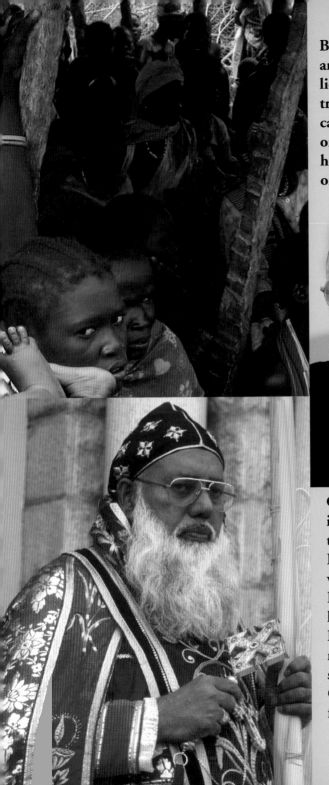

Beyond our rites
and traditions
lies a far nobler
truth: Christ
cannot be confined
or contained in
houses of marble
or robes of gold.

Clothed instead
in our humanity
the Word-made-
Flesh compels all
who call upon the
Holy Name to
heal the broken
Body of the Lord,
not just for our
sake but for
Christ's sake and
for theirs.

85

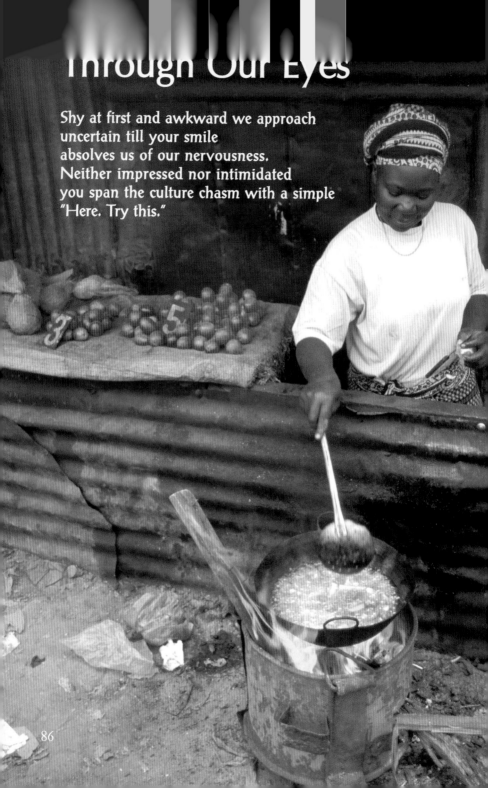

Through Our Eyes

Shy at first and awkward we approach
uncertain till your smile
absolves us of our nervousness.
Neither impressed nor intimidated
you span the culture chasm with a simple
"Here. Try this."

Too familiar faith
takes on fresh fervor
when we, once so sure
we knew Christ and
his Gospel, become
small again.

Lucky for us
we at first
do not speak your
language, or else
we might have no
excuse for our
silence.

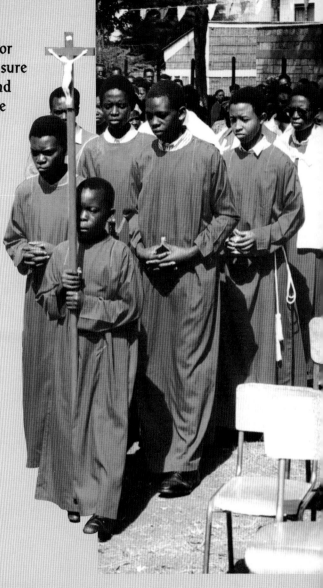

In truth we stand in awe
of you whose lives lack the luxuries
we considered absolute necessities.
Amid suffering and hardship
you draw from an inner well
and seem so solid and full.

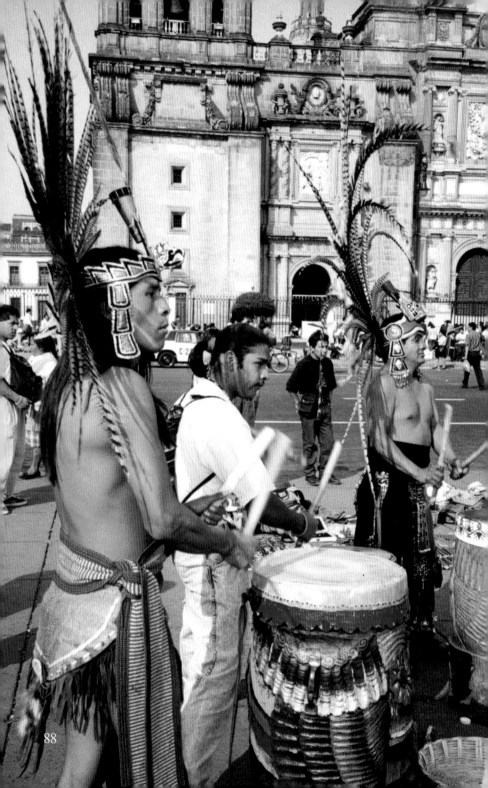

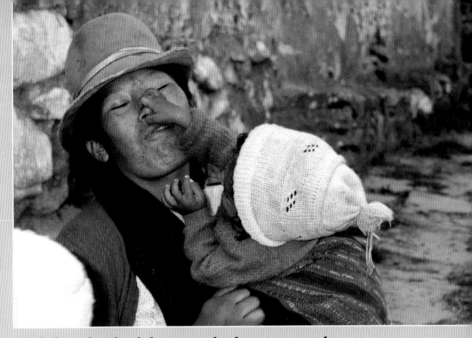

And then the shock hits us, who know so much:
We have so very much to learn. From you.
"Keep your dissertations and dogma till later," you say in your
own words and way; something like:
"Care for a yam? Have some kimchi. Eat some rice and beans!"

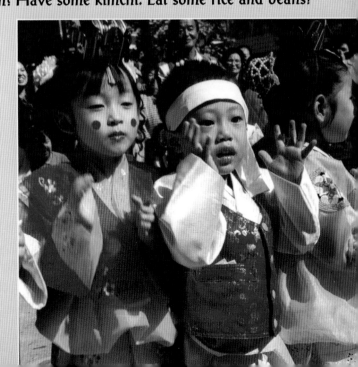

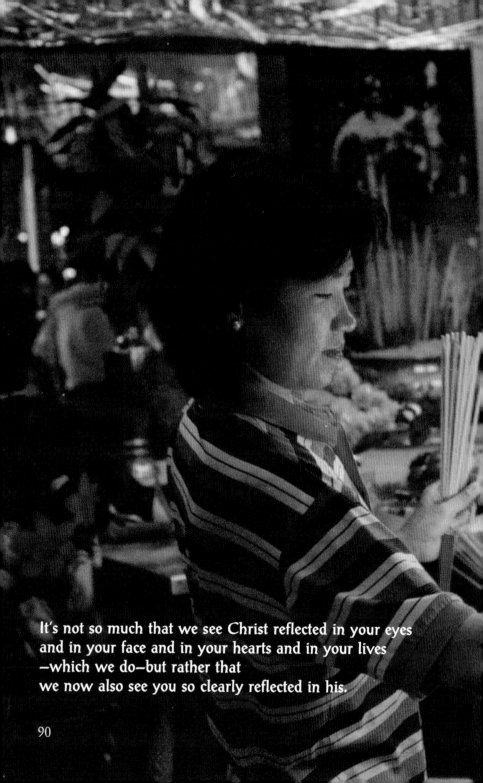

It's not so much that we see Christ reflected in your eyes
and in your face and in your hearts and in your lives
—which we do—but rather that
we now also see you so clearly reflected in his.

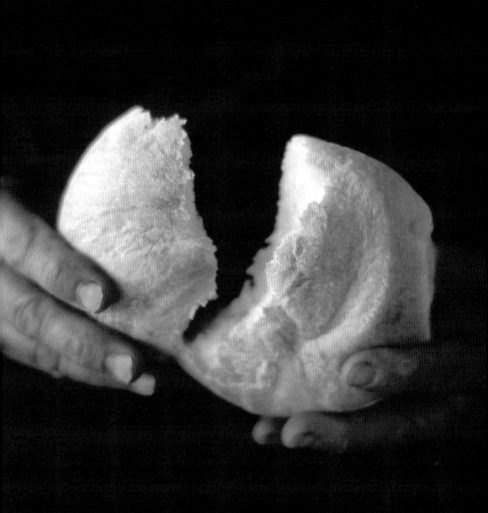

CHAPTER 3

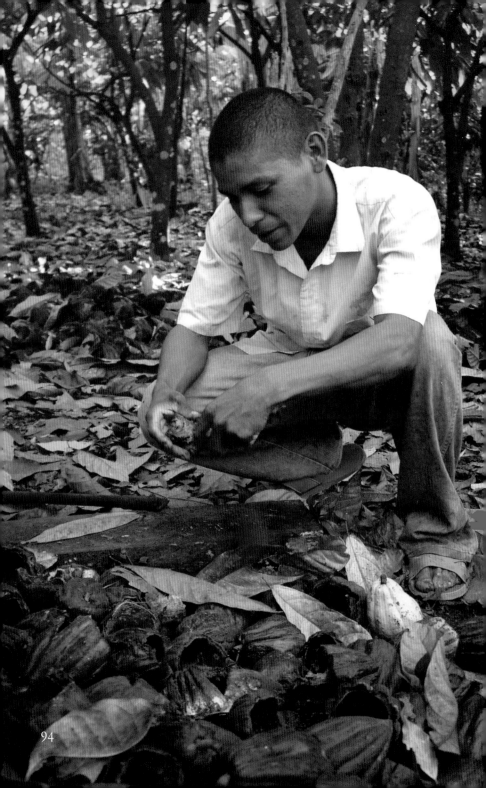

GOD IN BROKEN THINGS

Like most Catholics, I found the mishandling of the clergy sexual abuse scandal depressing. In a darkened church I vented my frustration. "How can I pray about mission and Maryknoll when everything seems to be falling apart?" I cried. "How can I call young men to serve a church crumbling before my eyes?"

Now I don't normally talk about hearing God, but in the depth of my heart I "heard" these words and leave it to you to discern their origin: "Oh, snap out of it. Stop feeling sorry for yourself. You are exactly where I want you to be. Besides, you're not calling anyone; I am."

Shocked, to put it mildly, I looked up to notice the sanctuary lights had come on, revealing a mosaic of the Transfiguration and the words from Luke 24:26: "Was it not necessary for the Christ to suffer and so enter his glory?" Not regrettable. Not unavoidable. Necessary. In the midst of the darkest of nights, Jesus took bread, and while breaking it, gave thanks.

"Eucharist" comes from the Greek word for giving thanks. Giving thanks to God, especially in times of trouble, is at the heart of our faith. When we do this in memory of Jesus, he is present to us in a unique way. Only broken bread can be shared. Only in the breaking of bread did the disciples on the road to Emmaus recognize the Risen Lord.

Perhaps the Church, as the Body of Christ, must also be broken for the presence of Christ to be revealed. Perhaps we, as the Body of Christ, must experience suffering and sacrifice in order to share our extraordinary life in God with others.

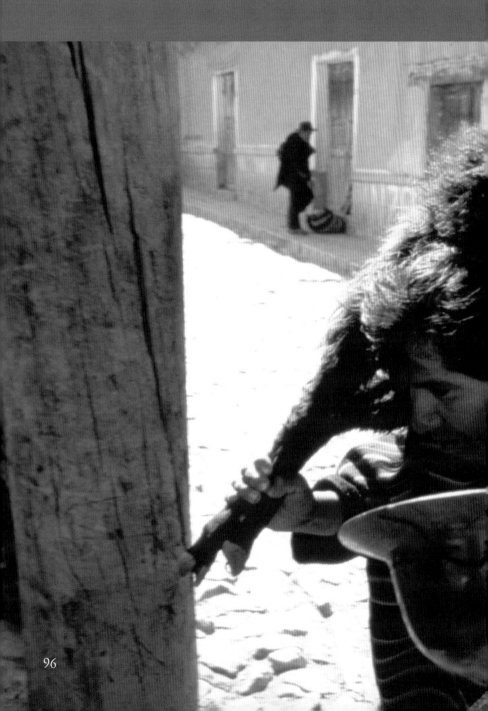

So there we were walking along
minding our own business—sort of—
when this perfect stranger butts in. The nerve!

What's worse, unlike us, he hadn't kept up
with the latest news. Talk about out of it.

I mean, this guy was like totally
clueless in Jerusalem.
Can you believe?

Did know his Bible. I'll give him that much.
Had a way about him.
Took all these terrible goings-on
and knew just the right words
to make it all make sense.

It came alive, the Word of God. Alive!
Could it be that God speaks to us
in these earth-shaking events
and through this Most Clueless Stranger!

Stay with us, we said.
Have some supper, we said. Some bread?
You really should put something on those nasty
wounds, we said. He replied, "Take and eat …"

It's him! we said.

Then he vanished.

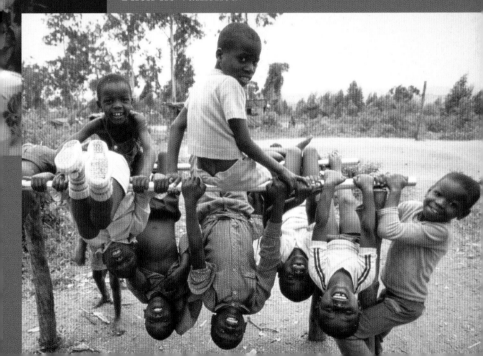

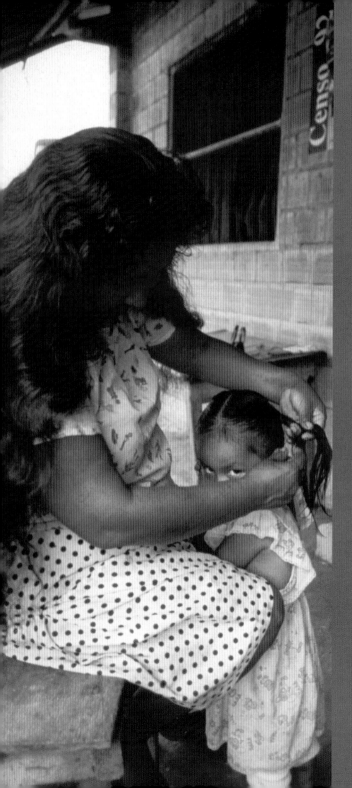

We believe
he is out there.

Waiting for us.

Calling us
to travel the
world in search
of the only one
who makes
our hearts
catch fire
and our lives
complete.

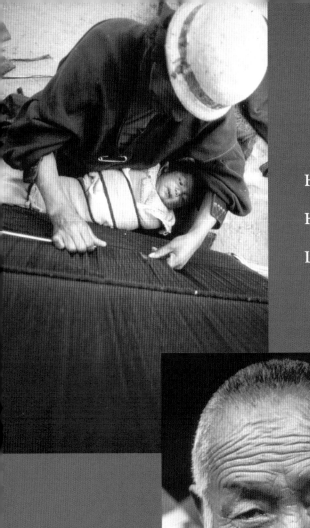

Have you seen him?

Help us find him.

Look around.

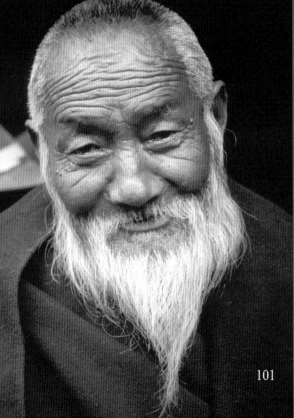

Heaven's Gate

They suffer most
who feel betrayed,
alone, abandoned
and unloved.

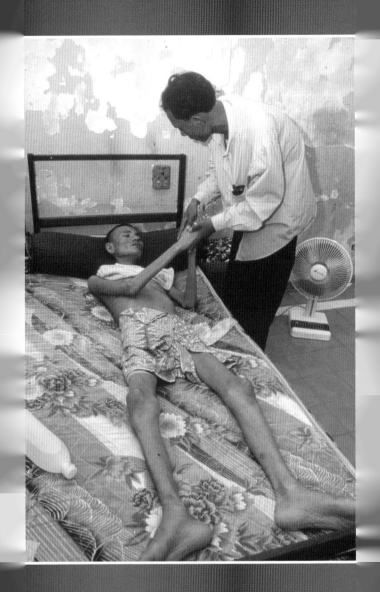

They suffer less
who know the healing touch
of gentle hands
and caring smile.

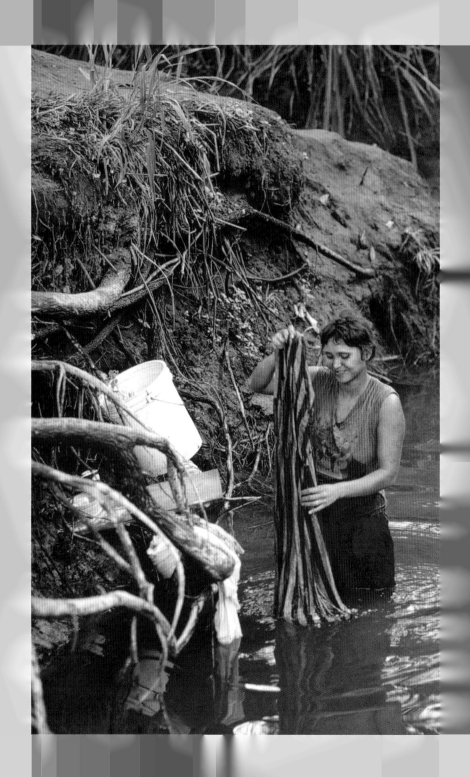

No one knows
what shape
the Cross may take,
its heft or size
or textured tone
but this alone
we know
with deadly
certainty:

It comes.

Respecting neithe
age nor race
nor gendered fait
nor social grace
it presses all
to earth in
its own time.
And yet,
those who bear
its load or share
for love
its weight
transform
the very jaws
of death itself
to heaven's gate.

Were It *Not* for Hunger

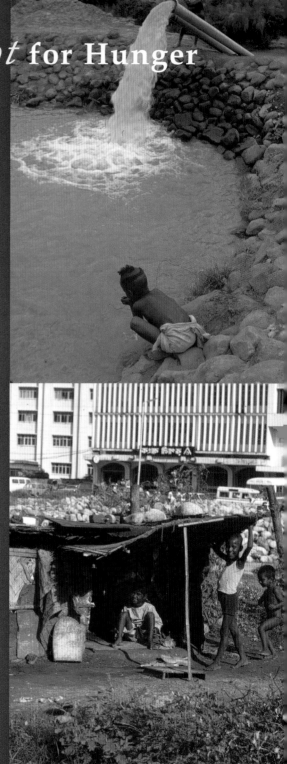

Were it not
 for hunger, Lord,

Would we thank you
 for our food?

Would grateful voices
 sing your praise

Would heartfelt
 alleluias raise

And shout hosannas
 all our days

Were it not
 for hunger, Lord?

Lord, were it not
 for poverty

Would we thank you
 for our wealth?

See you in
 another's face

And recognize the
 time and place

When you blessed the
 human race

Were it not for
 poverty?

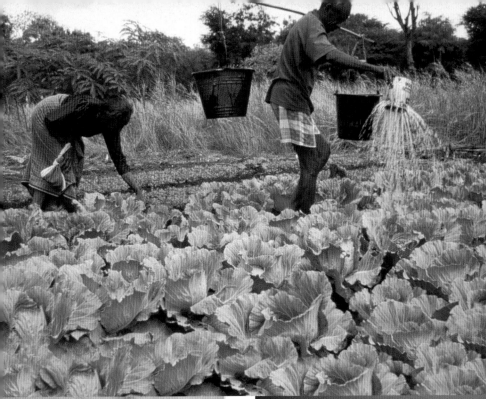

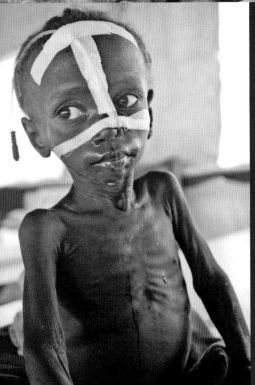

And, Jesus, were it
not for death

Would we thank
you for our health?

If old age did not
follow youth

And error not give
way to truth

Not eye-for-eye and
tooth-for-tooth

Were it not
for death?

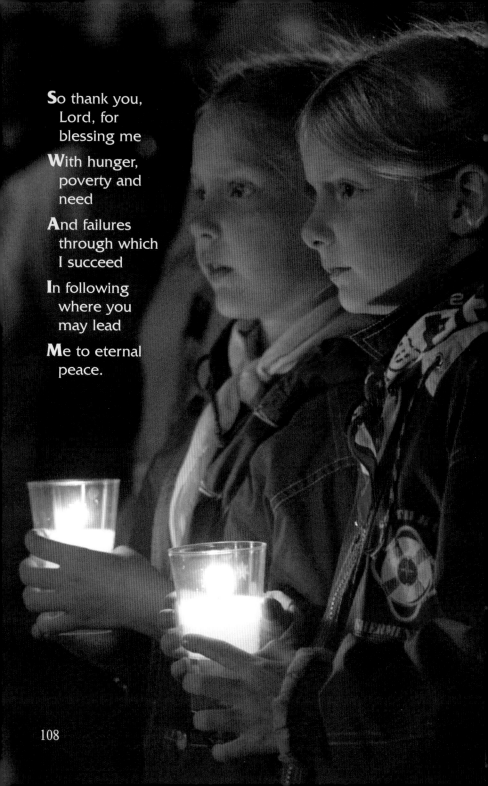

So thank you,
 Lord, for
 blessing me

With hunger,
 poverty and
 need

And failures
 through which
 I succeed

In following
 where you
 may lead

Me to eternal
 peace.

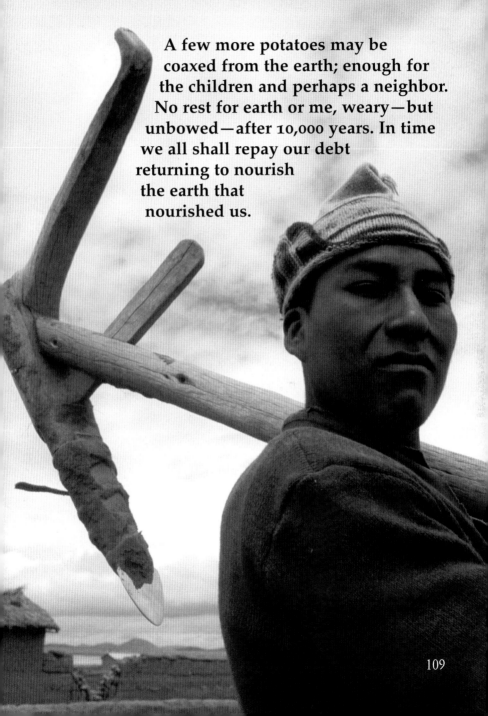

The Price of Tomatoes

A few more potatoes may be
coaxed from the earth; enough for
the children and perhaps a neighbor.
No rest for earth or me, weary—but
unbowed—after 10,000 years. In time
we all shall repay our debt
returning to nourish
the earth that
nourished us.

Cast on Praise be to God!
knit one My husband finally
purl two found a good job
knit two with that new company
purl one in Heliopolis.
cable stitch Traditional pattern:
needles, yarn husband, wife
Taking extra care not to drop a
stitch along the way lest the
whole thing unravel.

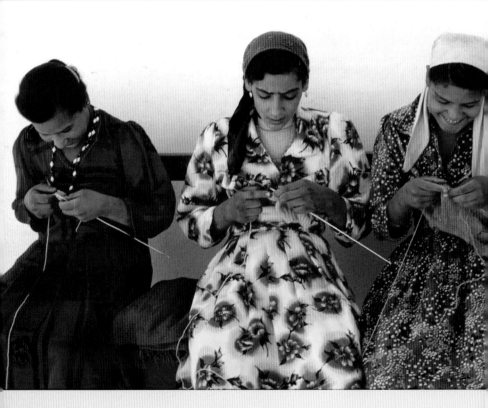

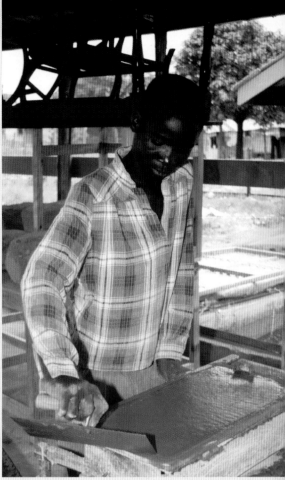

These bricks will last much longer than the ones my father used to make. Perhaps my son will make stronger bricks still. Perhaps my grandchildren will one day live in a house of bricks that someone else made.

Nuts and bolts. 1/2 inch. 3/4 inch. Each in its proper container. How many times have I told Hsien Xou, "Each in its proper container"? Now all the 1/2-inch bolts are mixed with the 3/4-inch bolts. Nuts.

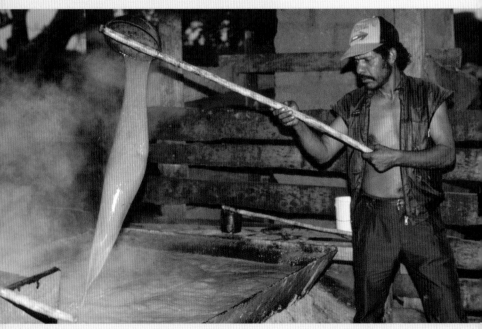

Sugarcane syrup. Sticky sweet. My job depends on folks far away putting this stuff in everything. Some dentist in a place called Indianapolis will discover a cavity in the tooth of a kid whose overweight mother wanted an excuse to diet and WHAM, next thing you know, I'm out of work.

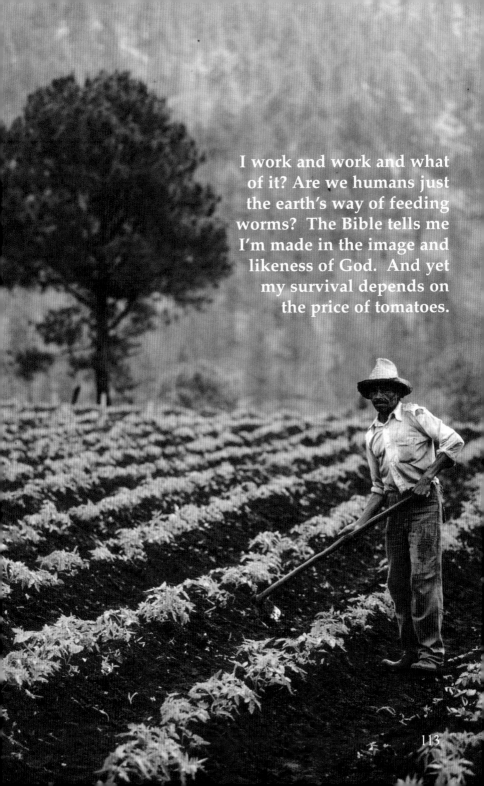

I work and work and what of it? Are we humans just the earth's way of feeding worms? The Bible tells me I'm made in the image and likeness of God. And yet my survival depends on the price of tomatoes.

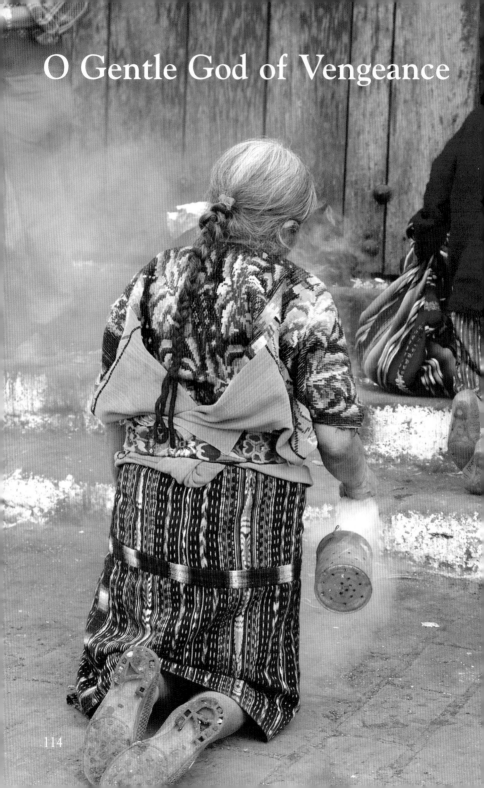

O Gentle God of Vengeance

O Lord,
no matter how much I pray
I cannot forgive them.
No matter how much I try
I cannot bring myself
to forgive you.

You, the All-Powerful,
the All-Knowing
the All-Merciful God.

Where was your power and
mercy when they did this?

Do you know what it's like to
have people insult you and
want you dead for just being
who you are?

Do you know how it
feels being the object of
scorn?

Crucified God,
Teach me to pray,
"Forgive us our sins as
we forgive those who
sin against us."

For only in living these
words do I experience
freedom and rebirth.

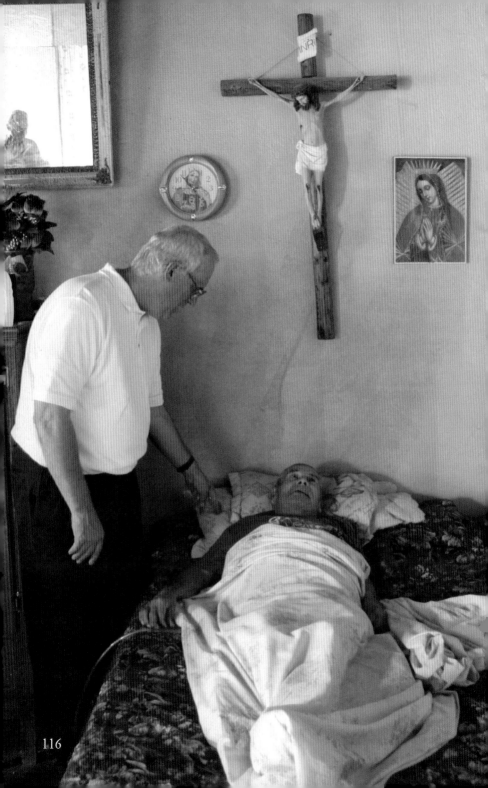

You, Lord, have given me the key to unlock the prison
 of my memories in which my salvation lies.
But Pride has rusted shut the door and Spite still stands guard.
Help me to see, to understand, to accept that until I forgive,
unless I renounce my urge to retaliate and let go of my grudge
I have placed my happiness in the hands of my adversary.

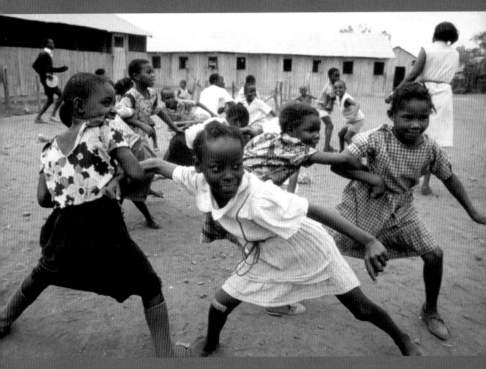

Therefore, O God of Justice, font of eternal Wisdom,
Grant that all my enemies may drown in the deepest ocean
 of your Mercy
Rain down upon their heads the unquenchable fire
 of your Love
Bind them securely with the unbreakable bonds
 of your Compassion
For only in this way will my wounded soul find Healing
 my heavy heart find Peace
 and my crushed spirit the lost Joy of my youth.

117

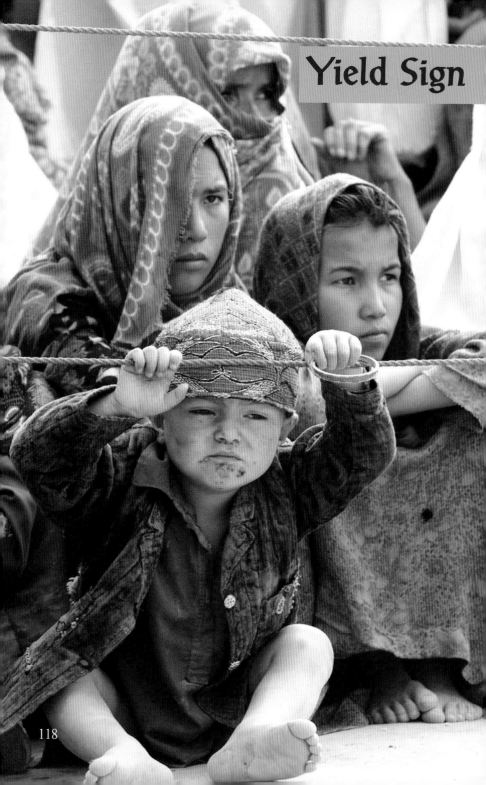

Yield Sign

of the Crossroads

I wandered lost in a land not my own,

along a path I did not know, bearing a cross of another's choosing.

I willingly gave up my habits; you asked for my heart.

I sacrificed my pleasures, but you remained unsatisfied,

until I was willing to give up my security and sacrifice my self.

Trusting, I placed my life in a stranger's hand,

confident that the One who brought me to this crossroad

will not remove all doubt but will remain forever by my side.

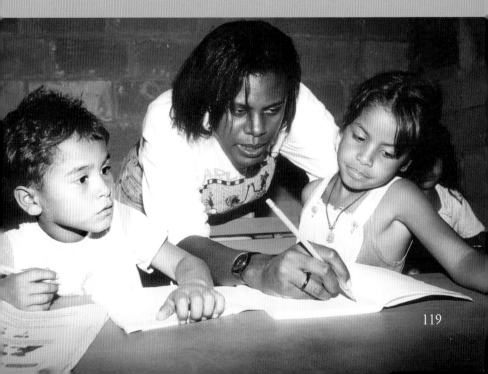

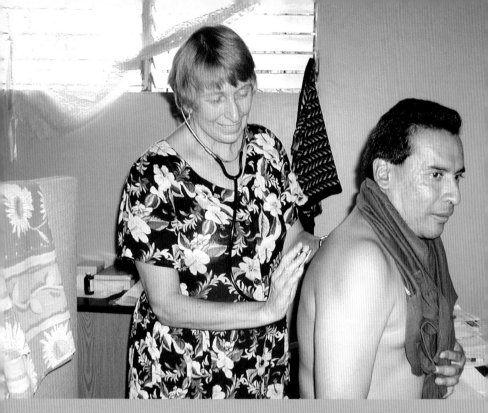

Touching, I heal.

Teaching, I learn.

Loving, I lose all and gain
the answer to my prayer.

Beyond the tears and sorrow,

beneath the pain and confusion,

hidden deep within your eyes

and in your voice and in your

smile, I find the One who called

me—and I am home again.

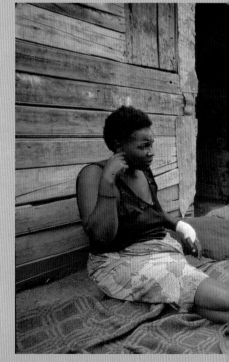

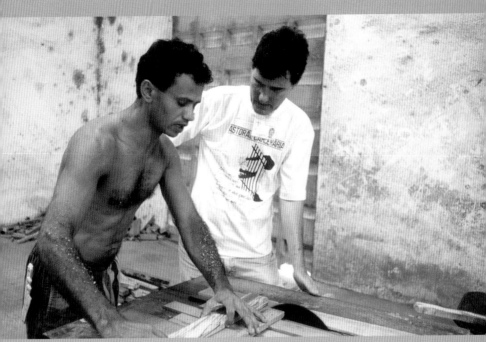

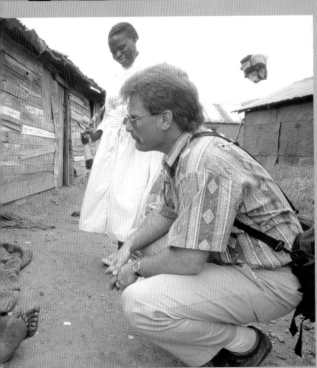

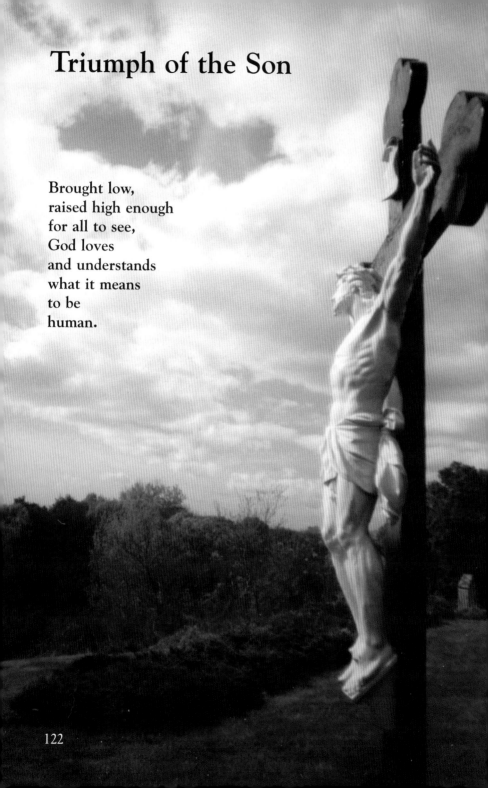

Triumph of the Son

Brought low,
raised high enough
for all to see,
God loves
and understands
what it means
to be
human.

Relentlessly pounded, kneaded, molded by the Potter,
then fired, clay becomes an earthen vessel
receiving, storing, pouring, overflowing,
finally breaking open to release
irrepressible torrents
of hope.

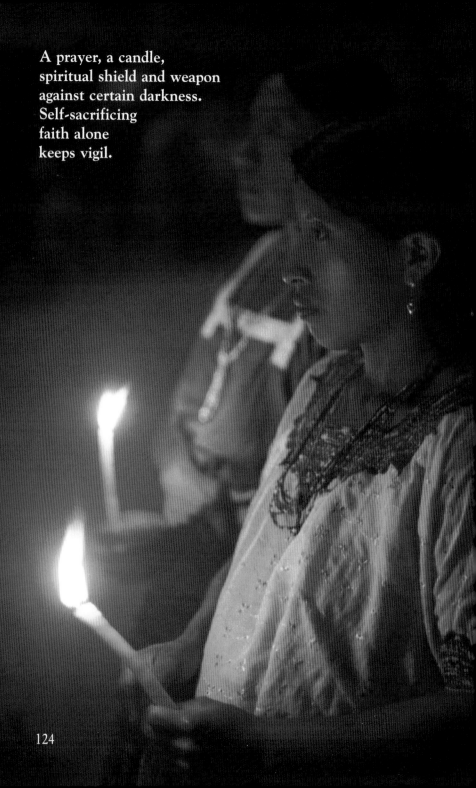

A prayer, a candle,
spiritual shield and weapon
against certain darkness.
Self-sacrificing
faith alone
keeps vigil.

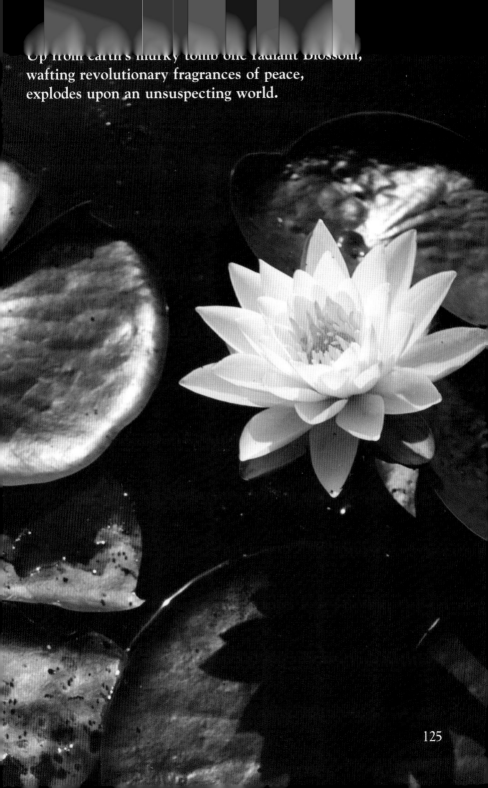

Up from earth's murky tomb one radiant Blossom,
wafting revolutionary fragrances of peace,
explodes upon an unsuspecting world.

God's Gentle Reign

Cloudbursts neither break a drought
nor quench long parchéd earth.

Nothing softens life-hardened hearts
like a steady, gentle rain.

On TV, loudspeakers broadcast
bigoted brimstone
boxed in biblical barb.
Annoyed viewers conclude:
Christianity oppresses.

Day's end finds no one
touched, no one
moved, no one
saved.

Meanwhile in some out-of-the-way
corner of a long-forgotten street
like some latter-day
Simon or Veronica
a reluctant saint bestows
an unexpected mercy.

Heaven opens. And then . . .

Coaxed by warmth and steady rain
even the harshest desert blooms.

A mustard seed
a lost coin
a measure of yeast
without drama
but with great mystery
wed heaven to earth.

For whosoever gives
one of these little ones
a cup of cold water in God's Name
shall in no wise lose their reward.

And the gentle reign of God
shall conquer all the earth
starting here
starting now.

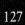

127

September
Mourning

ISLAMIC CHRIST
امية المسيحية

Crystal clear blue the sky
that day we watched in disbelief
taunted by the question Why?
united by a common grief.

The world, it seemed, was on our side
together we would face the foe
but all too soon our wounded pride
refused to listen, learn or know
the reason why so many died
or why some people hate us so.

Unrestrained we forged ahead
heedless of the human cost
ignoring calls for peace; instead
much more than innocence was lost.

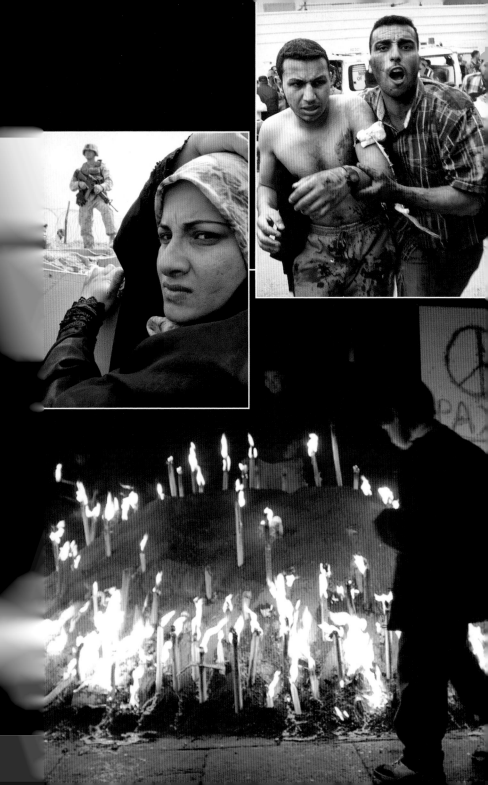

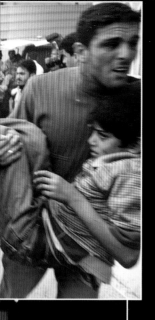

Eye-for-eye and life-for-life
we sank to what they said we were
spreading bloodshed, death and strife
causing what we would deter.

With the passing of the years
we weep for what to us was done
but let us also shed some tears
mourning what we have become.

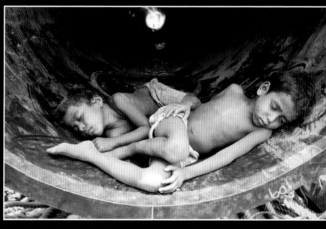

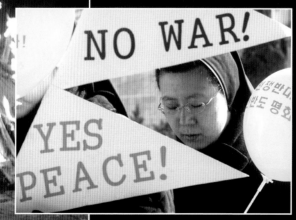

Manger Mystery

Where have all the shepherds gone
And wherefore did they leave their flocks
Amidst the ills and barren rocks
Before the coming of the dawn?

What urgency inspired them
Who bravely many dangers faced
Abandoning their posts in haste
To seek a Lamb in Bethlehem?

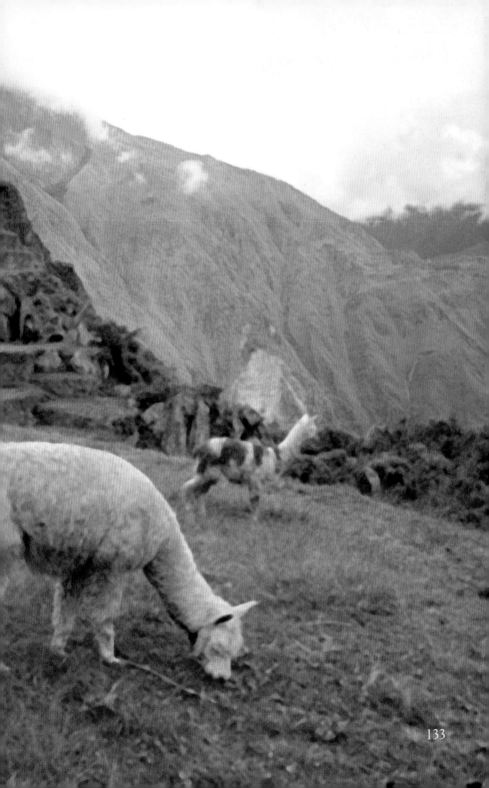

What further need have we of herds
To tend and guard on wintry nights?
For unto us is born this day
In lowly form the God of Heights.

But who'd believe what we have seen
And who would take a shepherd's word
that once upon a glorious time
A Child cried but no one heard?

While mighty kings in fitful sleep
Dread the thought of losing power
Filled with joy all captives weep
For holy freedom born this hour.

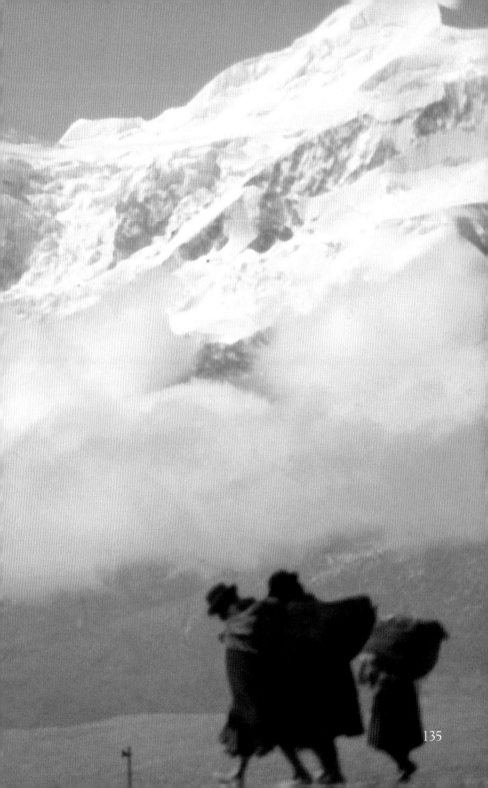

Take the clouds

Oh take the clouds from off your eyes
and see Me as I truly am
not hidden in far distant skies
but present in your daily lives
riding bikes or eating jam.

And take the clouds from off your minds
and recognize Me when I walk
beside you wearing different kinds
of clothing, offering different prayers
for truth be told the one who finds
Me simply is the one who cares.

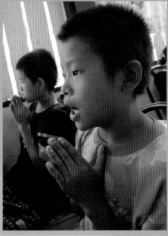

Take the clouds, too,
from your hearts
and love Me as
I truly am
and not as you would
have Me be.

For only then will you
be free to live your
life in harmony.
Life's a song
not a test
so give your
anxious minds
a rest.
Take courage
when I say
to you the best
is yet to be.

Come, then,
all you who seek
and look for Me
among the weak
the young
the old
the sick
the meek
the living
the dying
and the bold.

Decorate your
Christmas tree
with pictures
of humanity
for only then
will you find
the One who gives
sight to the blind.

You will know
then this is true:
God is human,
just like you.

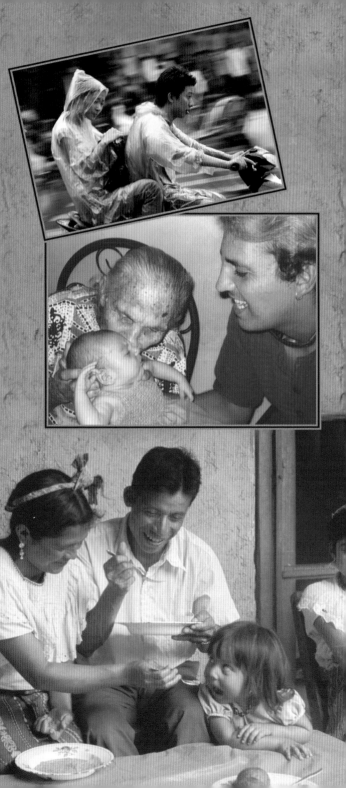

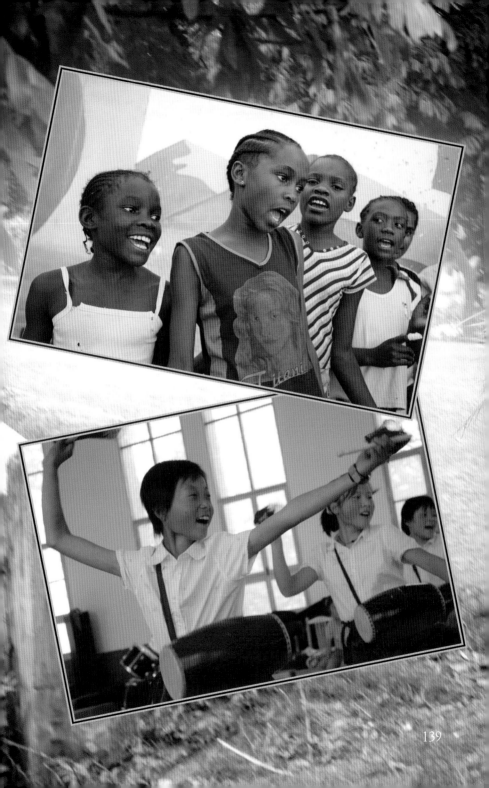

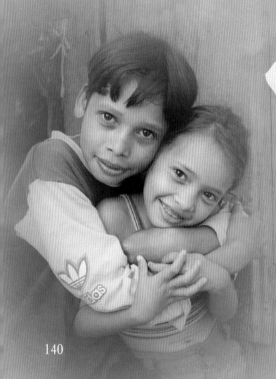

When God Breaks Through

Shalom

שלום

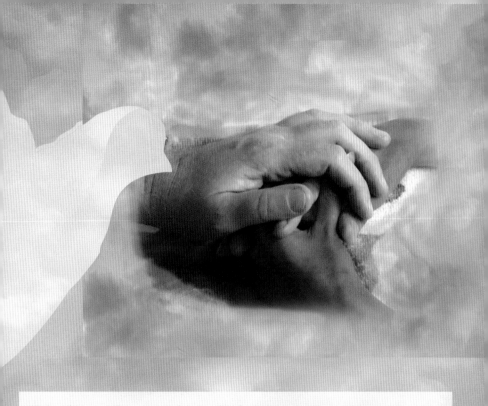

Shalom, he said and showed us
his hands, Shalom, his wounds, his side.
How did he get past our locked doors
more pressing than how he, once dead,
now stands in our midst alive? Shalom.

Risen though still wounded he appears
against all reason, logic, common sense
conferring on all with shattered hopes,
whose dreams go unfulfilled:
Shalom.

To those burdened, bowed and broken
through no fault of their own, or every,
comes an unexpected holy wholeness
wholly undeserved.

Peace, hello, health, goodbye,
completeness, in a word: Shalom.

In twenty: God knows us, loves us,
forgives us, heals us, wants us to be
like God totally alive
in love totally.

Shalom.

May the peace of Christ disturb you
like a grain of sand the oyster pearls.

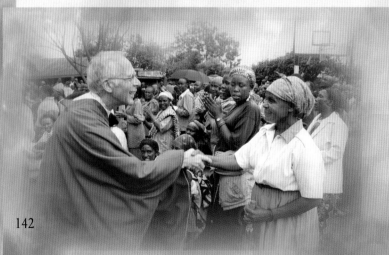

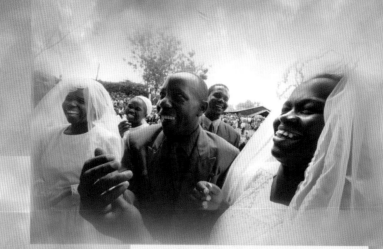

From the smoldering
ashes of a thousand
what-ifs and as many
might-have-beens
comes this life-giving
liberating word.

And we with hearts
broken by regrets
and disappointments,
crushed, perhaps,
beyond our ability
to endure, extend our
doubts to touch
the one who cannot be,
but is, and there and
then find the answer to
our deepest longing.

Photography Credits

Page 2: Sean Sprague/China; 14: Sprague/Korea; 16-17: John Argauer/Chile; 18: Lawrence M. Rich/Mozambique; 19: John Beeching/Thailand; 20: Sprague/Kenya; 21: Sprague/Thailand; 22: Joseph Towle/Bolivia; 23: Frank Maurovich/Chile; 24: *top* Robert Hoosier/Bangladesh, *bottom* David Johnson/Nepal; 25: Paul D'Arcy/Peru; 26: Argauer/US; 27: *background* Sprague/China, Argauer/US; 28: Sprague/Thailand; 29: Sprague/Tanzania; 30: Sprague/China; 31: Eric Wheater/Philippines; 32-33: Sprague/Guatemala; 34: *left* Doug Venne/Bangladesh, *right* Sprague/Indonesia; 35: *top* Sprague/Indonesia, *bottom* Sprague/Tanzania; 36: *top left* Mimi Forsyth/US, *top right* David McKenna/US, *bottom left* Argauer/US; 36-37 *center* Argauer/US; 37: *background* Forsyth/US, *right* Marty Costello/Galapagos; 38: *top left* Sprague/Cambodia, *top right* Sprague/Venezuela, *center* Sprague/Mongolia, *bottom left* Hoosier/Bangladesh, *bottom right* Sprague/Nicaragua; 39 *top* Sprague/Guatemala, *center* Sprague/Tanzania, *bottom* Sprague/Namibia; 40: Sprague/Burundi; 41: Sprague/Mexico; 42: Sprague/Indonesia; 43: Sprague/China; 44-45: Sprague/India; 46:Catholic News Service/Peru; 47:Sprague/Cambodia; 48: *top* Sprague/Cambodia, *bottom* Mev Puleo/Brazil; 50: Sprague/Guatemala; 52: Linda Unger/Tanzania; 53: Sprague/Kenya; 54-55: Patrick Henry/Peru; 56: *top* Kevin Thomas/Cambodia, *bottom* Thomas/Peru; 57: CNS/Mexico, 58: *top* CNS, *bottom* David Aquije/Peru; 59: *center* CNS, *bottom* CNS; 60-61: Sprague/Bolivia; 62: Beeching/Hong Kong; 63: *top* Jim Gilligan/Korea, *bottom* Sprague/Taiwan; 64: *top* Wheater/Israel, *bottom* Sprague/Tanzania; 65: Sprague/India; 66: *left* Sprague/Mozambique, *right* Hoosier/Bangladesh; 66-67: Sprague/Mexico; 68: Jim Daniels/Thailand; 69: *top* Wheater/Guatemala, *bottom* Sprague/Nepal; 70: *top* Wheater/Tanzania, *center* Wheater/Bolivia, *bottom* Hoosier/Bangladesh; 71: *top* Sprague/Nicaragua, *bottom left* Kathy Bond/Mexico, *bottom right* Maurovich/Chile; 72: *top* Sprague/Sudan, *bottom* Wheater/Chile; 73: Sprague/Venezuela; 74: Hoosier/Bangladesh; 75: Hoosier/Bangladesh; 76: Hoosier/Bangladesh; 77: Sprague/Thailand; 78-79: Hoosier/Bangladesh; 80: *top* Andy Rakoczy/Mexico, *bottom* Sprague/Venezuela; 81: *top* Hoosier/Bangladesh, *bottom* Sprague/Rome; 82: Sprague/CNEWA/Ukraine; 83: *top* CNS/Rome, *bottom* Sprague/CNEWA/India; 84-85: CNS/Sudan; 85: *left* Sprague/CNEWA/India, *right* CNS/Iraq; 86: Sprague/Kenya; 87: Frank Breen/Kenya; 88: Andy Marsolek/Mexico, 89: *top* McKenna/Bolivia, *bottom* Joseph Fedora/Korea; 90-91: Beeching/Thailand; 92: Forsyth; 94: Sprague/Nicaragua; 96-97:Sprague/Bolivia; 98: Sprague/Russia; 99: Sprague/Rwanda; 100: Sprague/Bolivia; 101: *top* Sprague/Bolivia, *bottom* Sprague/Tibet; 102: Octavio Duran; 103: Sprague/Cambodia; 104: Jeff Perkell/Nicaragua; 105: *top* Sprague/Mozambique, *bottom* Unger/Philippines; 106: *top* Karl Purcell/Africa, *bottom* Hoosier/Bangladesh; 107: *top* Sprague/Indonesia, *bottom* CNS photo from Reuters/Niger; 108: CNS photo by B. Roller/Germany; 109: Flip Schulke/Bolivia; 110-111: Wheater/Egypt; 111: Thomas/Kenya; 112: *top* Ron Saucci/Hong Kong, *bottom* D'arcy/Nicaragua; 113: Sprague/Tanzania; D'Arcy/Nicaragua; 114: Sprague/Guatemala; 115 *top* Sprague/Cambodia, *bottom* Sprague/Tanzania; 116: Sprague/Mexico; 117: Sprague/Kenya; 118: CNS/Reuters/Afghanistan; 119: Fedora/Venezuela; 120 *top* Bill Coy/El Salvador; 120-121: Sprague/Kenya; 121: *top* Fedora/Brazil; 122: Argauer/US; 123: Beeching/Egypt; 124: Sprague/Guatemala; 125: Argauer/US; 126: Sprague/Thailand; 127: *background* Myers/Peru, *insert* Sprague/Tanzania; 128-131: all CNS; 132-133: Joe Vail/Peru; 134-135: Towle/Bolivia; 136-137: Sprague/Vietnam, 136: *bottom* Sprague/Cambodia, 137: *top* Sprague/Thailand; 138: *top* Sprague/Vietnam, *center* Bond/Brazil, *bottom* Guillermo Castillo/Guatemala; 139: *background* Sprague/Vietnam, *top* Sprague/Namibia, *bottom* Sprague/China; 140: Sprague/Venezuela; 141: Sprague/Cambodia; 142: Sprague/Kenya; 143: *top* Sprague/Kenya. *bottom* Sprague/Mexico